How to Draw 1·11·87

Adrian Hill

How to Draw

Pan Original

Pan Books London, Sydney and Auckland

First published 1963 by Pan Books Ltd
This edition published 1989 by Pan Books Ltd,
Cavaye Place, London, SW10 9PG
9 8 7 6 5 4 3 2 1
© Adrian Hill 1963
ISBN 0 330 31226 X
Printed in Great Britain by
Cox & Wyman Ltd, Reading

CONTENTS

How to Draw

HOW TO DRAW

INTRODUCTION

THE IMPORTANCE OF DRAWING

WHAT IS drawing? Can it be defined simply as the act of representing by line in black and white? Surely if drawing is to be properly understood we must seek for some deeper meaning, for, apart from the physical act, it is sooner or later a personal expression of a mental or visual experience in terms of line and-tone. It could almost be described as pictorial thinking with a pencil on paper. In the past drawing has been, too often I believe, accepted merely as a technical method of creating the illusion of solid forms on a two-dimensional sheet of paper. It is more – much more.

To the art student, drawing (if I remember rightly) is presented primarily as the repeated scales or physical jerks by which he may become painting fit. Be that as it may drawing is certainly the most direct means of pictorial communication, as there is only a pencil between you and the paper! Eric Newton has described what prompts the artist to draw. 'It is,' he says, 'in the very nature of drawings to be diverse in their aim and therefore heterogeneous in their form. Sometimes they explore, untidily, the dark undergrowth of the mind, sometimes they work out with mathematical precision the stresses and strains of a pictorial idea. Sometimes they are memories in a visual shorthand of the artist's own devising, sometimes they are rapid notes of a thing seen in a flash and captured with a scuffle. And sometimes they have a finality of their own – neither drawings "of" or drawings "for", but ultimate drawings.'

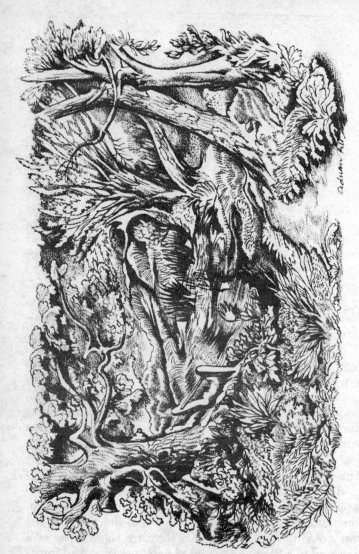

'Sometimes they explore, untidily, the dark undergrowth of the mind'

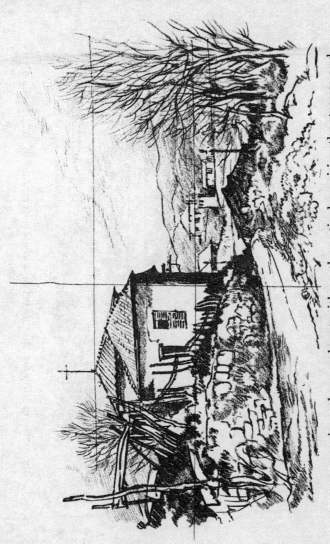

'... sometimes they work out with mathematical precision the stresses and strains of a pictorial idea'

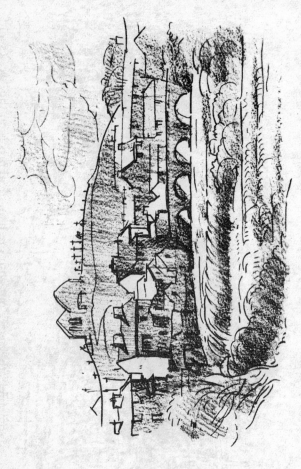

'Sometimes they are memories in a visual shorthand of the artist's own devising'

'. . . sometimes they are rapid notes of a thing seen in a flash and captured with a scuffle'

'Sometimes they have a finality of their own – neither drawings "of" or drawings "for", but ultimate drawings'

That I believe sums up what drawing is – and what drawings are for. Certain it is that drawing in whatever form it takes is indispensable to our aesthetic well-being and to neglect it is to forfeit any lasting reward that painting can offer. While drawing is in one sense a gift, it can be taught – that is what art schools are for. But to those who, for one reason or another, cannot avail themselves of such personal instruction, I would say that sufficient basic information can be imparted by the written word, which, if followed intelligently, can enable the reader to *begin* to make himself understood in much the same way as he can learn the essential vocabulary and phraseology in a foreign language of the country he desires to explore.

Drawing for the beginner, unless it comes to him naturally, is a form of communication not easily comprehended until the basic vocabulary is understood. And a book in which the principles are set out and their application explained must surely encourage the reader to accept the proffered help – and take the plunge! In looking back over the years since I first took up my pen to join the ranks of artist authors, I have had a recurring urge to write – and more recklessly – illustrate such a book as this, on drawing.

At the same time, I have had it increasingly on my conscience that, when all is said, and written, if the beginner is to communicate freely what he wishes to express, he has to learn *how* to draw, and the sooner that is realized the better! In my continual efforts to reconcile this task of *learning how* to draw with the promise of a richer enjoyment when *knowing how* to draw, I have had recourse to all manner of devices – for such I suppose they must be called – by which this necessary part of the performance can be undertaken with real enjoyment, evoking moreover, as much pleasure and satisfaction as that found in its actual attainment.

But to draw well – to be able to draw at all if it comes to that – must necessitate something very like hard work, for as any one knows, the concentration involved when the hand and eye and will to succeed are at full stretch, is every bit as

arduous as actual physical toil. And if in the end this must be admitted, then why not at the beginning?

At this point and when I have been most inclined to make an actual start on the writing, the knowledge of how much has been written and published already on this subject has arrested my pen and laying it down with a sigh I have reflected 'Surely it has all been said again and again.' The final decision has been reached by the comforting thought that by keeping strictly to my own personal experience, I may perhaps have stumbled upon another *way* of explaining the time-honoured truths. I have tried to keep the matter simple – simple words and simple examples. Many of the latter I have tried out on my students and, may I add, usually found them to work! I have long since decided that one diagram is worth a page of text, and my publishers have been accordingly generous with the illustrations which stand as evidence and must act as my witnesses for the defence – of drawing. I have always loved drawing for itself alone and although some contemporary art appears to get along without any apparent display of it, I trust that as the mighty beech tree is not too proud to exhibit its tenacious roots, so the 'roots' of all good pictures will be allowed to appear from time to time, for without the evidence of such foundations, some aspects of modern painting must surely be in danger of collapse!

THE PLEASURES OF DRAWING

THE PLEASURES of drawing which I would offer to the reader are not entirely dependent on achievement, although success, however small, is naturally one of the ultimate aims.

First and foremost there is the real pleasure of the adventure itself. With this goes the pleasure, the pure pleasure, of doing it for its own sake, of losing oneself in the job, when time is no longer of any account, when the finished product, so often disappointing, does not really matter, or does not matter so much! For how many times, when admitting that the result of our best efforts has not 'come off', we realize how happily occupied we have been while actually at work – or wrestling with the problems on hand. Then there are the pleasures of trying again ('I must get that right!'), the pleasure of discovery ('I never knew that before!'), the pleasure of triumphing over technical difficulties (and how many there are!). These are the concepts of pleasure which I have in mind and which I hope to justify in the following pages when dealing with the pitfalls – the 'near misses' and the honest-to-goodness failures – which beset our path; for all of them, I hope to show, have their pleasant aspect. For myself I have even derived downright pleasure and satisfaction from destroying a whole heap of drawings, not a few of which at one time were thought to be quite remarkable achievements (pictures that I had fondly believed 'held up the mirror to Nature' but that were afterwards found to be but reflections in a distorting glass!). At such times I have realized that a faulty image wears remarkably thin over the passage of time, and when it is exposed in all its pictorial shabbiness, what a pleasure it is to be done with it.

Another factor not to be overlooked in this manifold definition of pleasure is that which has its origin in a becoming modesty, for it must be remembered that when we thus consider our drawings and offer them for criticism, the pleasure of being told that we have improved (perhaps 'out of all

knowledge') is one that we can savour to the full, knowing that it is in all probability quite true! Students, it has been said, divide themselves into two categories – those who are principally interested in their craft and usually imitate their masters; and those who are determined to express themselves and are usually careless of craft, floundering clumsily along in the hope that a style will sooner or later emerge. It is to both – but especially to this latter and more enterprising class – that such a book as this is hopefully addressed.

TEACHER AND STUDENT

BEFORE I embark on the problems (as well as the pleasures) of drawing, I would like to try to clarify some muddled thinking which is common to both instructor and instructed.

Firstly, the great veneration that the average amateur has for the average professional artist and all he says and draws sometimes proves a heavy handicap to the development of the amateur's personality.

Secondly, the awful authority which the teacher unwittingly exercises when he pronounces some rigid dictum of technique or composition is sometimes found to conflict in a bewildering fashion with what is apparent in some of his own pictures. Indeed the very same sins for which the trembling amateur has been roundly admonished are often glaringly obvious in the master's own productions!

Such inconsistencies of precept and practice can be reconciled only if the teacher – yes, and the student – remain alive to the fact that individuality is a rare and precious possession which can easily be devalued by an overdose of didactics. It is one thing to have a wholesome respect for the experience that a professional artist brings to his craft; it is quite another to retain a slavish reverence for everything he produces – or says, or *writes* – for this can only lead to a surrender of the student's urge to be himself.

To bridge this gap between blind belief in all instruction and 'putting hubristic fingers to the nose' in defiance of all technical counsel is one of the major difficulties that face the author and his reader. So much of the written word would seem to need amendment in order to cover the particular requirements of a particular student whose immediate case lies outside the purpose of this book.

To some such reader much of what I shall advocate as beneficial to his performance or outlook may appear not only unnecessary to his artistic diet but repellent to his aesthetic palate. The results obtained from such methods

when seen in the accompanying illustrations may well con-
firm his honest distaste for the mixture! 'I don't want to
draw like that,' he will probably complain. And although it
is easy to imagine such a grievance, it is less easy to write out
a prescription for his unknown ailment. I can only hope that
to the sceptical, the timid, or the staid student, the following
suggested course of study may not appear as a task and if
attempted will prove congenial and beneficial in actual
practice.

One of many objections to a change of method (which I
may suggest) is that the amateur has often been told to 'do
it' in a certain way, and because of long usage this way is no
longer accounted a problem to be overcome! Indeed it has
become instinctive – natural: just as in the technique of con-
versation such verbal solecisms as 'Pleased to meet you' as a
form of address, and 'Ever so nice' as an expression of
appreciation, have become 'natural'!

In the art of picture making, I believe that many a student
or amateur has a lurking suspicion that the 'pleased-to-
meet-you' sort of subject and the 'ever-so-nice' drawing
may not be 'ever so nice' after all! And none of us should
be so odd or rooted in a particular habit that we do not feel
the itch to escape, however clumsy our methods of extrac-
tion may appear to the less adventuresome.

BEGINNERS PLEASE

Line upon Line

'I CANNOT EVEN draw a straight line.' I wonder how many times this explanation or confession has been made when the question of drawing or painting arises? We all know what is meant. But what is actually said is that such a 'simple' exercise as drawing a straight line is quite beyond their powers, and that before they have mastered this trial of skill, they are automatically precluded from any form of art activity! Now if we take this statement on its face value, then of course it is perfectly true that, without the aid of a ruler, drawing a straight line free hand needs, as 'The White King' would have said, 'plenty of practice', but failure to draw such a line 'dead straight' matters little, for this very inability to attain absolute straightness is very often an actual advantage rather than a hindrance to drawing. (And I am always tempted to ask in return, 'Who wants a perfectly straight line anyway, and if it is absolutely vital, what is wrong with using a ruler?')

Having now I hope exposed for ever the fallacy of this time-honoured cliché, we can take up our pencil with renewed confidence, despite the fact that we must use a *line* whatever we draw! Let me put it this way. When we begin to draw any sort of line we can be said to start on a journey – and we leave a tangible trail behind us. It is *our* trail and we make it in *our* way. Where we go and how we go is of our own choice. With practice we can soon make a more or less direct non-stop journey from one side of our paper to the other (Fig. 1). Or we can make our way in a more leisurely fashion, mounting and descending at will, steering a very roundabout course, so much so in fact that if our line was a piece of string and straightened out, it would possibly extend far beyond our paper and even the board on which our piece of paper was resting (Fig. 2). But curled up on our paper it makes a *design* – of sorts. Again, we can begin our

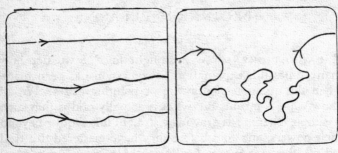

FIG. 1 FIG. 2

line straightish (not *straight* you note!) and then from the
horizontal direction we can make it shoot up (or down) at
any particular point and at any particular angle we wish,
and having returned we can continue again on our hori-
zontal journey (Fig. 3). Now obviously such a line becomes
exciting at that point where we decide to mount or descend.
Such a sudden and unexpected change of direction is more
arresting than if we *curved* our line upwards or downwards.
So we see that an angle formed above the line, like the sil-
houette of a church steeple – for that is what it will suggest –
can be very effective against the sky (Fig. 4). In fact any

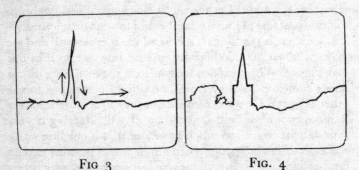

FIG 3 FIG. 4

diversion, fluctuation, or wavering from the straight and
narrow is welcomed as a break in the monotony of our jour-

ney. You see I want you to get interested, really interested in what a line can do, or rather what *you* can make a line do. And I would insist that a 'wobbly' line is always more lively than the mechanical straight line. If you look closely at any of the seemingly straight lines which occur in any of my diagrams, you will see that none of them is dead straight. And if they are nearly so, it only shows you how easy it is after you have mastered the control of your pencil!

All ideas, it has been wisely said, start with the pencil. Even hard-headed business men sitting together discussing some project or other can often be seen to produce a pen or pencil to make their meaning clearer by drawing lines. 'No, look, this is what I mean,' you would probably hear one of them say, for having failed to make his idea plain in words, he naturally resorts to the universal language. For that, of course, is what drawing is. And if all ideas start with a pencil, then it is true to say that it is the pencil that makes the line that leaves the trail which creates the form which expresses the idea, rather like the house that Jack built (for Jack must have had a pencil when he first thought of building himself a house!). The idea grows as the line gives it life and meaning.

Let us explore the possibilities of this line a little closer. A line can be all powerful. One line drawn in the right place can create the heavens and the earth, for is that not what we call the horizon line? Above is the sky, underneath is the earth or the sea. In one movement, then, we can divide the elements. A line, apart from creating a form, may suggest repose or create excitement. It can be used like the inflexions of a voice. It can express movement; travel swiftly or move in jerks – indeed on occasions and out of control, it can be said to lead us a 'pretty' dance!

But I hear an objection now being raised. 'It is all very well for you – you *can* draw. I cannot – I should only scribble.' To which I should reply that even a so-called 'scribble' can be an interesting line! Especially if it denotes exasperation! That well-known scribble, for instance, which

cancels out what you have been trying to draw. 'Oh, bother the thing' (or stronger!) 'I can't do it' – and a furious whirligig of angry lines blot out the original effort! Well, such a line or lines are very significant. They certainly express our feelings and like a burst of temper are better out than bottled up! Explosive, no doubt, but how descriptive! (Fig. 5). And as soon as we realize how effective such a line can be, we can produce it again to *order* – when and where

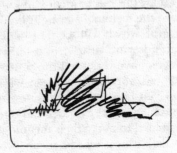

FIG. 5

it is required. And when it is under our control, it will cease to be 'just a scribble', for as irony or scorn is more effective than a burst of uncontrolled temper, so our line is that much more expressive than our original gesture of disgust. Does all this sound rather far fetched, or too much like a game? In a sense, of course, drawing *is* a game, a mystic game with all sorts of magical possibilities. For as we gradually assume authority over our pencil, so we find we are performing a kind of ritual in which there are endless variations. Our only properties are a pencil and paper. How simple! Like a conjuror we have the power to produce something out of nothing. But there the simile ends, for there is no sleight of hand in drawing, no deception, unless creating the third dimension on a two dimensional sheet of paper must be accounted a delightful deception, and that certainly is going on all the time we are at work.

The pure line (if we believe that it was practised as long ago as twenty-five thousand years in the caves which have been discovered in recent years) can then be said to be the origin of all the art that has since stemmed from those prehistoric times: a form of language which can be read as easily today as it was when the cave man traced his record on the walls of his rude home. And how descriptive they

were; how modern in conception; how contemporary in execution.

The Importance of a Frame

You will notice that all the diagrams which illustrate this text are framed. And I draw my frame first. I give myself a shape which I am then responsible for decorating. I have often been asked why the size and proportions of my pieces of paper should not act as a frame. And my answer is this. By drawing a border inside your paper, the shape inside is of *your making*. This emphasizes its importance, for this frame can be a different shape from the size of your paper – it is not dictated by the dimensions of the paper. I have rarely seen a beginner think at all about where he is going to start a drawing – his sheet of paper is, or appears, limitless, and half the fear of starting to draw is similar, I should imagine, to the dread of making a journey in a limitless desert. But once you have the boundary lines in sight, you realize the extent or limits, if you like, to which *you* may explore and this gives confidence.

And when we come to consider the importance of the shapes left between our line or lines and the sides of our frame, we shall see how true this is, even though we may be still in the 'doodling' stage (Figs. 6, 7, 8 & 9).

What is 'doodling'? Tracing lines or shapes without thinking? Or drawing while thinking about something else? I believe that as soon as your pencil starts making shapes of any kind, then you can be said to be *drawing*, whether you are consciously or unconsciously directing operations. And as I have been at some pains to point out, if you have first given yourself a shape – horizontal, or oblong, your so-called 'doodle' must begin to make something and that something will begin to stir your imagination. 'Doodling' on a blotter, the edge of a sheet of newspaper (or on the walls of a telephone kiosk!) will always remain meaningless because they have no limits, have no frame, so they peter out. But once you have made your own self-imposed boundaries, your adventures in line must willy nilly compose themselves into

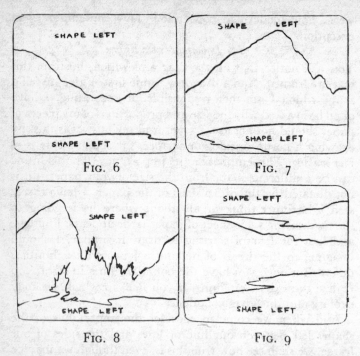

FIG. 6 FIG. 7

FIG. 8 FIG. 9

some design, for wherever your line goes, it must stop short
at the top, bottom or sides of your frame. For this reason,
you will find it better to begin your line from the *side* of your
frame and continue in varying directions until you meet the
other side – and have to stop! The following examples I
hope will explain more clearly what I have in mind and
when understood should stimulate you to start experiment-
ing yourself and quite literally see what happens!

The curved line of adventure. Try and draw the line A–B
without withdrawing your pencil from the paper. This will
give you power over your pencil. What do we see? A river,
or a road? Or do the spaces left Y, X, suggest solid bodies?
(Fig. 10).

By drawing lines C, D, E, F, the space above Y becomes
a solid and at once we are on the top of a cliff! By drawing in

line H we have created sky and water, and by adding K, we have divided water and beach! (Fig. 11).

From there, we can add more details (Fig. 12). A footpath, a notice board, trees, rocks, clouds, etc., and remember it all began with the curved line of adventure A–B (Fig. 10).

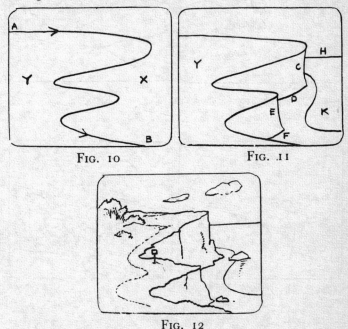

FIG. 10 FIG. 11

FIG. 12

Now let us leave the coastline and adventure inland.

(1) A to B is a very wavy line. Does this suggest any form? Clouds, for instance? If so, then it would be·better if we drew it in *higher up* – (Fig. 13). This will give us more room for introducing line C to D which divides sky and earth. Lines E and F will give us distance. (Fig. 14).

But if our original wavy line suggests the silhouette of trees (Fig. 15) then X and Y will establish this suggestion, and we can still use the wavy line A–B for the outline of clouds (Fig. 16).

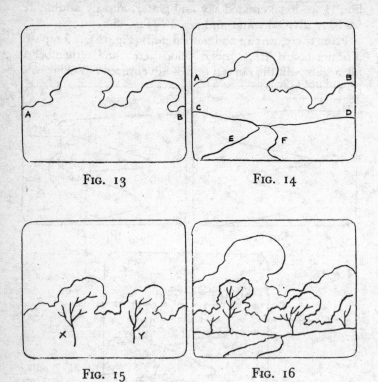

FIG. 13 FIG. 14

FIG. 15 FIG. 16

OBJECT DRAWING

OBJECT DRAWING is often considered a dreadful bore, especially if it is presented as a task. And to the majority who do not take kindly to a pencil it can be viewed with real dread. To draw, whatever the object is, with accuracy – if that is the sole test – demands concentration and necessitates many rubbings out in which there is little pleasure and small satisfaction in the result.

Nevertheless there is a lot to be said for object drawing. It all depends, I believe, on what you want to get out of the exercise and how you approach it. I am sure it is very important to *want* to draw something because of its shape or unusual proportions, and in order to get the best out of your study you should make a number of drawings of the same object in different positions. With very few exceptions, such as bottles and vases, without handles, round fruits, etc., most objects present quite different shapes when viewed from varying levels and positions. These diverse viewpoints always reveal the same object – or should do – and the interest is in seeing how many different drawings you can make from the same object.

Let us see what we can do with a simple shape, like the bottle for instance. At first sight there do not appear to be many variations on this unpromising theme but it is possible to ring the changes many times without any trouble. And when you have finished you will certainly know more about bottles, their design and proportions, their fitness for purpose – not only as a bottle but as a pictorial accessory! And if you make a page of such drawings, you will be forced to think about composition, and this can often be forgotten. A page of sketches, remember, can be designed just as well as anything else. You are then *using* your studies as it were, for picture purposes.

And from simple shapes you can go on to more complicated and interesting objects such as can be termed *bric à*

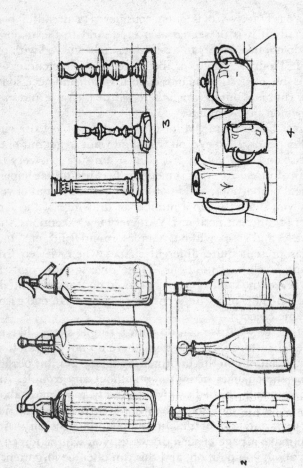

1. Different shapes of the same object
2. Different shapes of different bottles
3. Different designs of a similar object
4. Different shapes of a unit

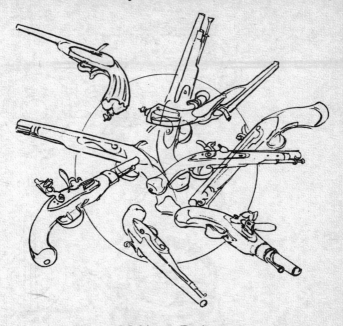

Making a Design

brac, in which curved lines can still predominate. I think you will find, however, that the former simple objects are not necessarily *easier* to draw than the latter. There is not so much to hang on to as in duelling pistols (see illus.) which present so many more 'amusing' shapes. And these offer you greater freedom of execution. In other words, the pistols were more fun to draw, or to try and draw! And I use this word 'fun' deliberately because it so often denotes a measure of success, as when a student has shown me his efforts with the comment, 'I had a lot of fun with these.' I think you will agree that the following pages of drawings all make good designs. The reason, of course, is that I sometimes super-imposed one study on another and thus integrated them into what might almost pass as an abstract design.

This sense of achievement rarely comes after the first

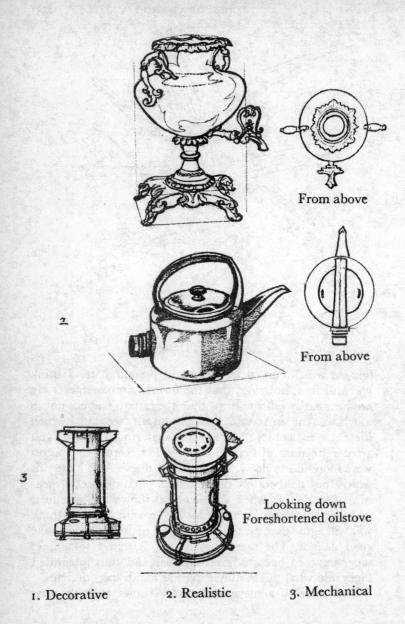

From above

2

From above

Looking down
Foreshortened oilstove

1. Decorative 2. Realistic 3. Mechanical

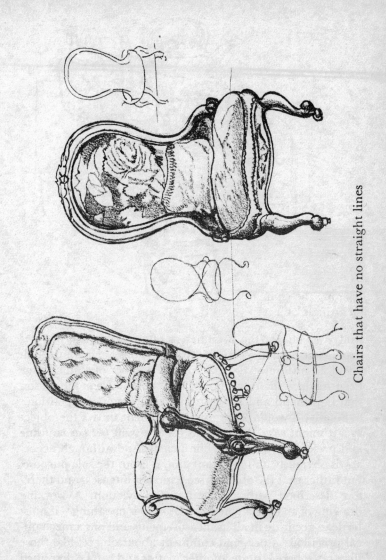

Chairs that have no straight lines

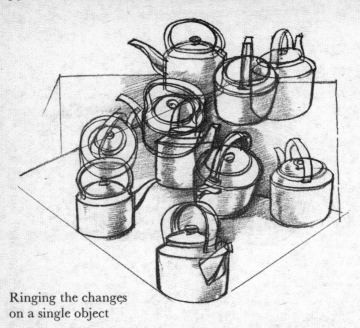

Ringing the changes
on a single object

study, which, for the beginner, is often a struggle, but it *is*
experienced when a series of drawings has been completed.
I will admit, however, that after a number of studies have
been made a slight falling off may be noted for the reason
that both hand and eye begin to tire from over-repetition.

Finally, I would urge that the student draws the object
as if it might *move*. This means using a swift *free hand* outline
and preferably with a carbon pencil. And although accur-
acy is obviously an important aim, it is not the sole purpose,
but rather that the object is seen and felt intensely and there-
fore described with a measure of conviction. A working
drawing of an object which is *to be made* is one thing – it must
be dead accurate in all its measurements and has a mechani-
cal precision: a personal comment about objects like those
illustrated here is quite another matter and can be described
as an artistic estimate or specification, to be enjoyed as such.

CHAPTER FIVE

ROUND THE HOUSE

THERE IS always plenty to draw – or rather to practise drawing on, in your own home. Each room contains sufficient solid objects, hanging, standing, or supporting, which offer good subjects for your pencil. Take the hall, or the passage, where hats and coats can be seen. Hanging clothes make first-rate studies and those garments which are hastily flung over a chair, how well the fortuitous arrangement of folds compose. The Victorian hat stand, draped with overcoats, garnished with a variety of headgear and flanked with sticks and umbrellas, makes a most diverting model, and if not usually found in the modern dwelling can be run to earth in many a modest restaurant or dining-room of a country inn.

The lounge, dining- or drawing-room at home invariably boasts a collection of *objets d'art*, which if not always antique (or even in the best taste) make interesting studies and often only justify their presence when, with loving skill, they are depicted in their proper place – the sketch book!

Furniture in its accustomed place round the walls can often be overlooked but if moved about (when, for instance, the room is spring-cleaned) it suddenly becomes alive – pictorially alive – for then new shapes are revealed, fresh contours and angles disclosed, offering a happy fortuitous composition for a careful drawing.

The kitchen too (not an unfamiliar room with most of us these days) will take on a new and attractive look, for the very presence of a pile of unwashed dishes stacked on the draining board, or a market basket spilling its contents of groceries or vegetables on the kitchen table, will instead of lowering our spirits rejoice our eyes and our fingers will itch for a pencil. The shelf of the larder cupboard can in itself provide a galaxy of pictorial 'nourishment'!

Exercises in perspective will present themselves when mounting or descending the stairs, especially on looking

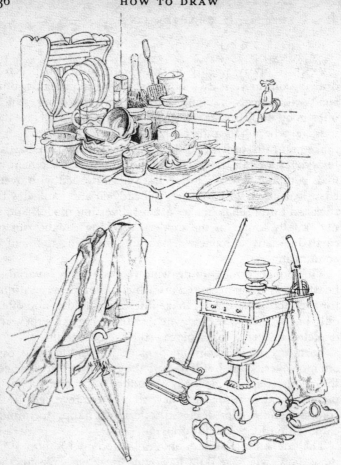

down from the top! In bedroom and spare room where per-
haps the tumbled bed is still unmade, there is ample refer-
ence for the discerning eye. In the bathroom, even the
ancient geyser becomes a model worthy of study! And best
of all the attic or loft, if it be full of junk – dilapidated
trunks, discarded pots and pans, obsolete picture frames and
the wartime oil stove – these offer a treasure trove which
will amply reward our labours. And on our return along the

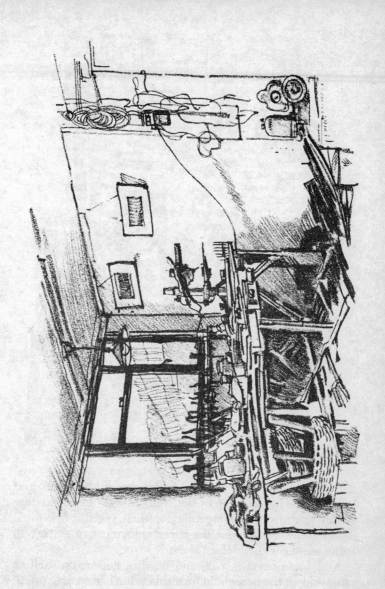

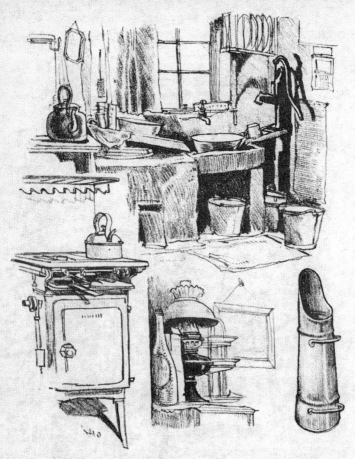

landing perhaps the Hoover or broom or dust pan and
brush, breaking the line of the wall, will be found exciting
things to draw, not altogether for their possible use for a
definite picture, but for the sheer enjoyment of getting to
know them for themselves alone.

And when curtain, rug, and bowl of flowers on shelf or
table and all the household furnishings have been exhausted,

there is always the window and the view outside. Looking down on the garden may often offer a better composition of greenhouse, pergola, lawn, or flowering tree than can be obtained when we are in the garden itself. This can also apply if it is only a yard on which we look, where our neighbour's washing seems permanently on view. Clothes on a line, hanging corpse-like in the sun, or stirred by an impish breeze into a frolic dance should be shrewdly observed and noted down with swift precision.

THE ARTIST'S WARDROBE

As IN the theatre, so in the studio, the artist brings in his properties by which he furnishes his pictures with authentic detail and to enhance them with pictorial interest. In Nature the number of such 'props' is almost unlimited. And all, at one time or another, are grist to our picture making, however mundane, insignificant or peculiar they may at first appear. The dustbins by the back door, or the portico over the front. The lamp-post up the road, the pillar-box at the corner, the telephone kiosk and the ruthlessly lopped suburban trees in the garden opposite – all these are so familiar as to be often overlooked. And when we reach the open country, the farm gate – left open (but not by us!) and the swinging inn sign, the rickety fence which flanks the village pond, the rustic stile, the church porch, the village pump and petrol pump, the signposts and motoring signs, the telegraph poles and distant lofty pylon against the skyline, and the butt of a felled tree by the roadside – how easy to miss all these which await our recognition and acquisition. And as you will have seen by my list, the modern innovations I have included are just as pictorially serviceable as the more picturesque ingredients which have served the artist so well in the past.

If these are carefully drawn (and carefully preserved) they will time and again come to our rescue when seeking for some authentic addition to complete our drawing or give verisimilitude to our landscape. True, we can nearly always call to mind the kind of property we require, but it is rare to remember just 'how it goes'. Here then we can build up a really comprehensive reference library for all emergencies! But I must add that a single study of a lamp-post, for instance, gives no choice and the fun begins when we start making a collection of different types of lamp-posts (and what a number there are to be found, from the graceful Victorian design to the quite hideous concrete erections like

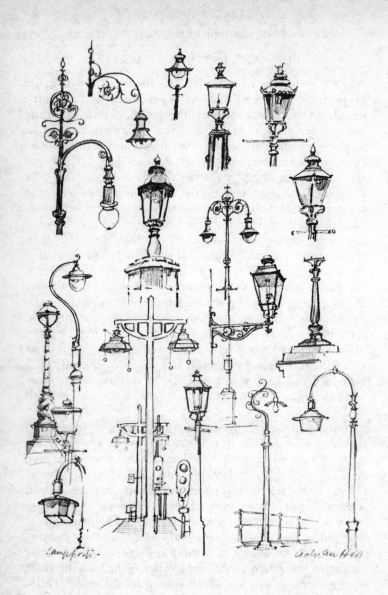

Lampposts aduan Hill

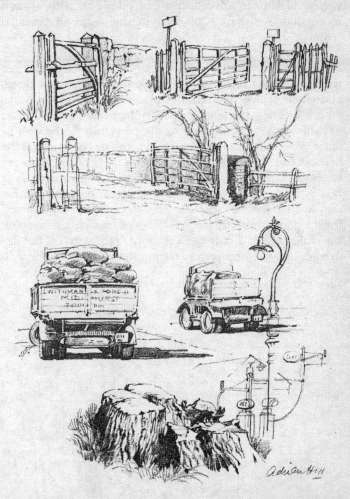

giant gibbets – awaiting the corpse – which flank our arterial
roads). And the same, of course, applies to fences, gates,
telegraph posts, roofs, steeples – everything, in fact, for there
is a bewildering variety of every known object made by man
to be found out of doors and these together with an infinite

variety of Nature's own forms can supply us with all and more than we shall ever need in the shape of pictorial 'copy'.

But we have got to be diligent and seek them out; they are not all found in the 'shop window' and when discovered we should select the best position from which to draw them, and when drawn they should include their working parts, for it is little use turning up a study of a barred gate if it does not show how it is fastened to the posts and to the wall or fence, any more than an inn sign which does not include the bracket and its attachment to the wall. Believe me, it is easy to leave these details out and it is only when your study is brought into use that you discover the operative line is missing. Such references as these may very often be purloined from a photograph, indeed it is why so many artists employ the camera, and I only use the word 'purloined' if the desired detail or object is drawn straight from the photograph

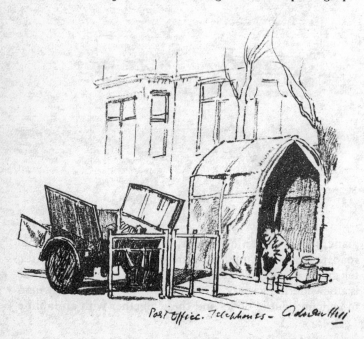

Post Office. Telephones - Adrian Hill

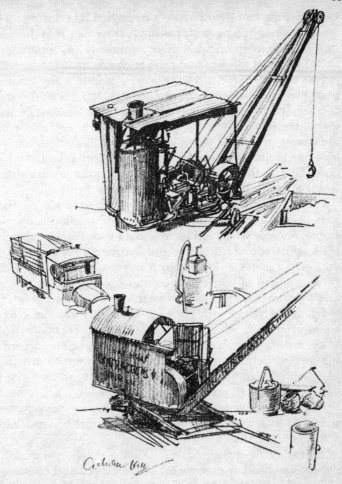

on to your picture, because when this happens the 'new-comer' never seems to fit happily into your drawing (or painting). It always has the appearance of a stranger dragged in to complete the company. This can be obviated only if we first make a separate study from the photograph.

Our drawing can then be safely translated into our picture for by making a separate drawing first we can introduce it into our composition with more confidence, as something we know about already and can vouch for.

By such means we can legitimately include many studies from photographs into our sketch books, but I would warn the beginner that only by *drawing direct from the object* do we get *all* the information we want. Strong light and shade in some photographs (which is very effective in itself) can mislead one badly when precision of outline is required. And a good bold outline is indispensable to a working drawing, whatever John Ruskin said to the contrary!

On these occasions when collecting information on the spot, you will often be standing up and precision is not so easy to achieve when you have to hold your block or sketch book while you are drawing and it is next to impossible if your paper is not supported by a stiff cover. I mention this because a pad of paper with a limp cover demands a seat and the comforting support of your knee to rest it on.

Naturally it frequently happens – as it does with me – that a study has to be left incomplete. It is still excellent practice to see how much you can get down in the time and according to the circumstances. I remember starting to draw the platform of a country station, while waiting for my train which, because I was on a very branch line, I was sure would give me plenty of time, only to be overtaken by the wretched little train coming in dead on time, before I had achieved more than a few lines.

And when we attempt making studies of living and moving objects, like horses, cows, or people, speed and economy of line is essential and rarely then can one make a detailed drawing, unless of course the horse is held or is between shafts, the cow sits down, or the human being goes to sleep, and it is a comforting thought to know that all these static states can occur.

There is small excuse, however (unless it rains), not to continue with our study of the inanimate object until we

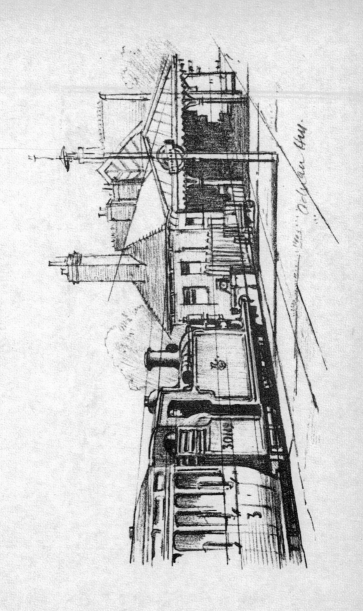

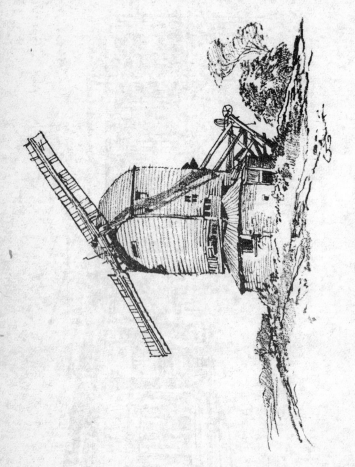

Derelict Mill

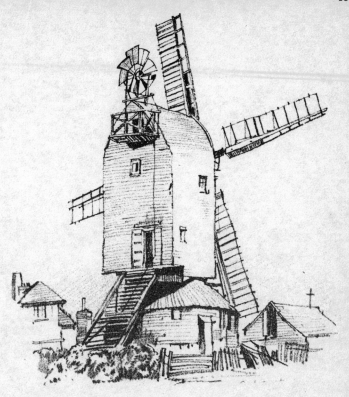

Working Mill

have come to grips with its characteristic shape, for these
are the kind of drawings which can safely be used without
loss of their fundamental structure, and found to work. And
a *pretty* drawing that does not work is a pretty feeble sort of
drawing!

LIGHT AND SHADE

NOW IT is time to consider how we are going to *light* our drawing. And you cannot have light without *shadows*. So if

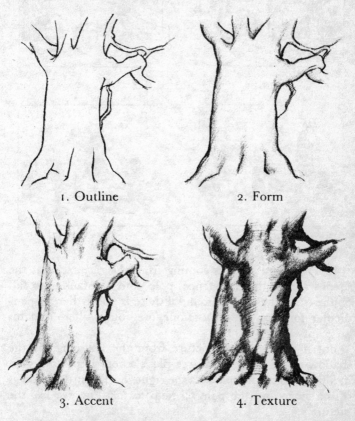

1. Outline 2. Form

3. Accent 4. Texture

our picture is to look right we must remember to determine where our light is coming from so that we keep the shadows going the right way! Now we can light our picture say, from the left- or the right-hand side. Let us see what difference this can make in a simple landscape.

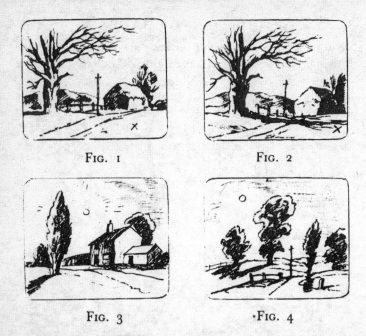

FIG. 1 FIG. 2

FIG. 3 ·FIG. 4

In Fig. 1 our light is coming from the *right*, so that the shadows from the tree, fence, pole, and haystack must fall on the *left* of these objects, and if there is no further perpendicular form on the *right* of our foreground, there remains an empty space, X.

But if we light our picture from the left (Fig. 2) the shadow of the foreground tree plays a very important part in filling this empty space on the right, X. The little shadows of the fence and the pole all help to take the eye *into* the picture.

And this (Fig. 3) can happen when the student forgets which way the light is supposed to fall. You may say you would never be so foolish as to commit all these faults, but I have seen many pictures where the light and shade are in constant conflict, and the picture looks definitely *wrong*.

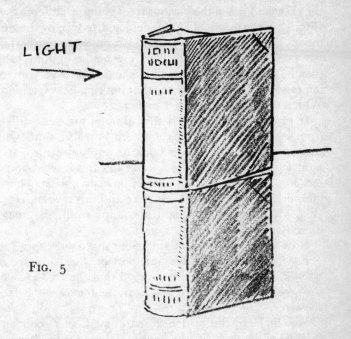

LIGHT

FIG. 5

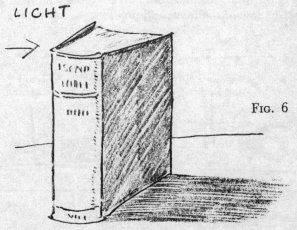

LICHT

FIG. 6

Not so noticeable as in Fig. 3, but almost as confusing are the cast shadows of the various trees going in different ways (Fig. 4). If the origin of light is depicted, as it is, by the sun or moon, then the trees are being lit from other sources!

Once the student has decided how best to light his subject then he must stick fast to a plan of action. It is very interesting to see the great difference that lighting has on a picture. Which do you prefer, Fig. 1 or Fig. 2?

It must be remembered that *shadows* are very different from *reflections*. Reflections are seen *in water*; shadows are cast *on solid earth*. Stand a book or any object in a strong light on a *solid* surface like a table and this is what you will see (Fig. 6). But place the book or bowl on a sheet of looking glass or the highly polished surface and this is what happens (Fig. 5). Wherever the light is coming from, the image is directly *underneath*.

Now let us see how this works out in a landscape.

Fig. 7. Here the bridge and post on the bank are seen *reflected* in the water of the river, so that the *shadow shape* of the arch and the pole are *revealed* in the *transparent* surface of the river.

Fig. 8. Here the bridge is spanning a *solid* road so the shadow of the arch (its thickness) falls *across* the solid road as does the shadow of the telegraph pole.

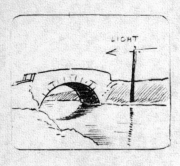

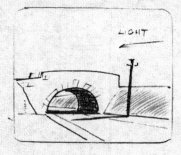

FIG. 7 FIG. 8

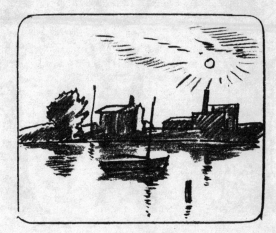

RIGHT

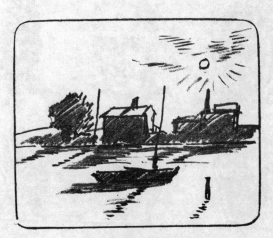

WRONG

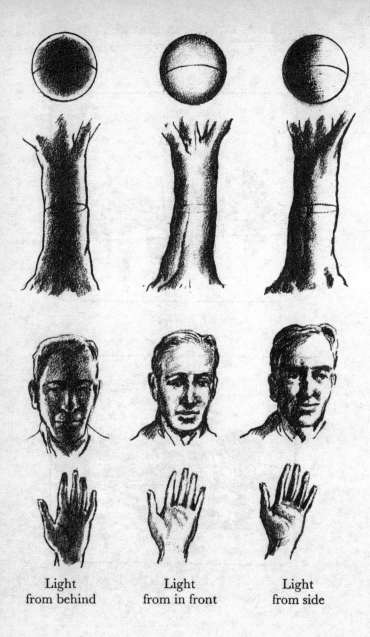

Light
from behind

Light
from in front

Light
from side

Cast shadows and their uses in
revealing form in buildings

SHADOWS AND REFLECTIONS
AND THEIR USES

WHEN WE are thinking in terms of a toned drawing I want
to enlarge on the subject of shadows. We have seen how
they can improve and even save a composition and I have
already warned the beginner about inconsistencies of direc-
tion. Here I want to say something about their actual in-
fluence on individual forms, especially architectural ones.
How often some building has been overlooked, simply and
solely because it has been seen in the wrong light. On a dull
day, for instance, everything can appear flat and un-
interesting. An even light, be it bright sunlight, can play
havoc with solid forms. Nothing seems to project or go back.
All we see is a mass of detail and all the detail appears of
equal interest. Although a glance at the outline betrays the
fact that the façade is far from being flat, there are no cast
shadows to help us in distinguishing between the various
recesses and those portions which jut forward in buttress or
roof; all appear on one plane.

We shrug our shoulders, heave a sigh of regret, and pass
by. We dismiss it. It does not, as we say, make a subject. But
the truth is of course that it does not make a subject at that
particular *time*, time of day perhaps, time of year, or merely
under that particular light. The sun that rises in the east,
we should remember, does not retire until it arrives in the
west! In other words, shadows are a matter of time, the time
when they occur and the time they last. And sometimes this
period is very brief! I know of course that often it is im-
possible to revisit a particular locality and look again at the
rejected subject. But I do know that if we do return, we will
often be surprised and delighted to see our erstwhile view, so
dull and lifeless before, now transformed into a lively com-
position through the agency of strong light and shade.
Shadows by their very power to obscure have now disclosed
significant detail, enhanced by being surrounded by dense

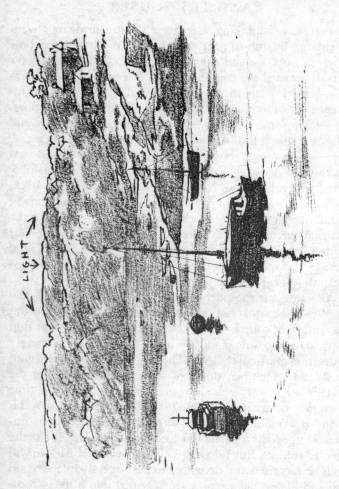

LIGHT

Reflections. Early morning sun

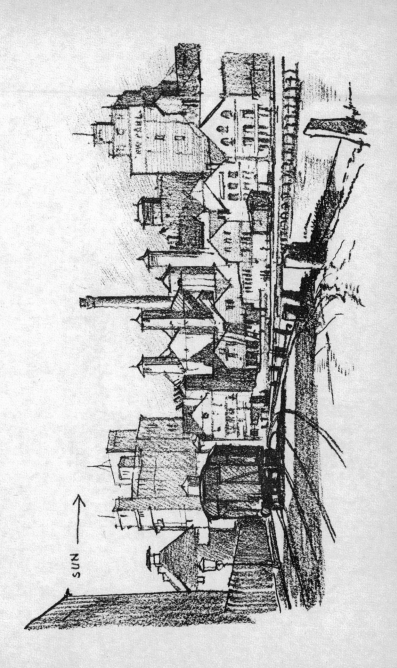

Reflections of trees in water

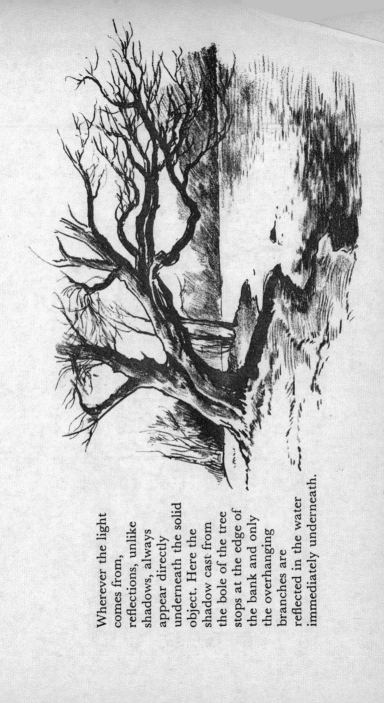

Wherever the light comes from, reflections, unlike shadows, always appear directly underneath the solid object. Here the shadow cast from the bole of the tree stops at the edge of the bank and only the overhanging branches are reflected in the water immediately underneath.

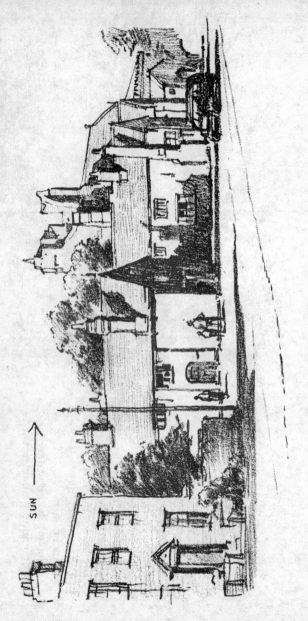

SUN →

Shadows. Evening light

shade in which would-be rival detail is blotted out. We are lucky indeed if we happen upon a subject on which the light is behaving as it should. It may well be that we arrive before the shadows have made their best impression, or if too late, the whole building may be in danger of being enveloped in a shroud – that is the luck of the game of 'hide and seek'. But in any case we would be wise to note the time and check the position of the sun and sit awhile to see what happens when light and shade, hand in hand, wander up and over, in and out, hiding and revealing in turn the architectural merit of our subject.

Cast shadows – top light – midday

VIEWPOINT

MOST BEGINNERS when they try their hand at picture making look down on their subject from what is called the 'bird's-eye' view. In many cases this is a very attractive viewpoint, as it enlarges the field of vision and discloses much more than if the subject was seen from the ground. But it often happens – in fact I would say always happens – that there is no choice in the matter. The beginner, like the child, cannot see any other way of drawing the subject because they do not understand perspective. To them, the road, or the river, must follow a perpendicular direction, and try as they may, they always remain 'air borne', and so the river always goes up hill! 'I wish,' they complain, 'that I could draw the subject as if I were on *the ground* and not in an aeroplane.'

Well, here is one way to keep 'grounded', and if the subject matter of my illustrations is very simple, I have done this purposely, so as not to confuse the issue with extraneous detail. Let us imagine, then, that you are looking out of a first storey window of a house on the front of some seaside resort. The frame of the window encloses the picture you see. What you see *within the frame* will be your picture. Of course if you move back from the window you will see less; if you move close to the glass you will see more. So we will sit still and keep our first position, say about one foot from the window. Now what you will see is roughly what I have drawn in Fig. 1, and alongside this view I have drawn your position with regard to your subject from the side – a section of the house and esplanade.

Level with your *eye* runs the horizon line (A–B) of the sea across the window, and between that line and the top of the window is the sky. In proportion to the depth of your picture (i.e. the frame of the window), the sky portion is well above the half-way line and at once you realize that what you are going to draw is what we call a *high horizon* picture.

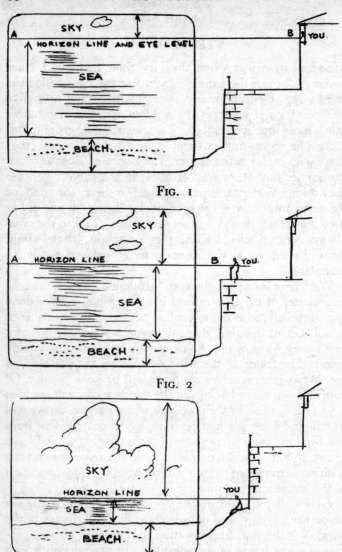

FIG. 1

FIG. 2

FIG. 3

But if you *descend* and stand on the esplanade and lean over the railings on the *front*, your eye level will come *down* and with it the horizontal line of the sea – i.e. you will see *more* sky, *less* sea (Fig. 2).

Now, if you go *down* on to the *sands*, again your eye level will be correspondingly lower so you will see *more* sky, and still *less* water and sand (Fig. 3).

Lastly, if you *sit* on the sands, the horizon line will obediently *fall* still *lower*, and the amount of sky will increase accordingly.

So now we have a low horizon picture, of the *same subject*. In this case the sea and beach have been 'concertina-d' almost flat, and unless there is a very beautiful sky, it would hardly be worth drawing or painting.

Of course, if you lay *flat* on the *sands*, the subject would be practically all sky!

Let us introduce some rocks and see how it works out (Page 66). Let us try one more example (Page 67).

Looking down, as if you were in an aeroplane, this is how you would see the river, bridge, banks, and trees. This is *all* you would see because if you raised your eyes to the horizon you would be looking *up* and right out of the picture (Fig. 7).

If you were standing on the deck of a barge this is how the bridge, river, banks, and trees would appear. But now you could include the sky (Fig. 8).

And lying in a punt you would see quite a lot of sky *beneath* the arch of the bridge (Fig. 9). But not so much of the tree on the left and nothing of the tree behind the bridge on the right.

But to the very beginner a subject such as 'the river, the bridge, and the tree' presents one baffling problem. Cajoled into action – to get something down – the river is generally represented by two parallel lines C and D which are drawn vertically from the bottom to the top of the paper. The bridge which is rightly envisaged as going *over* the river from one side to the other is depicted, after some ineffectual 'gestures' with the pencil, by two curved parallel lines A

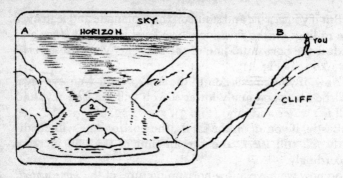

FIG. 4

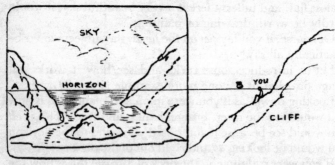

FIG. 5

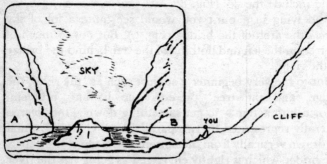

FIG. 6

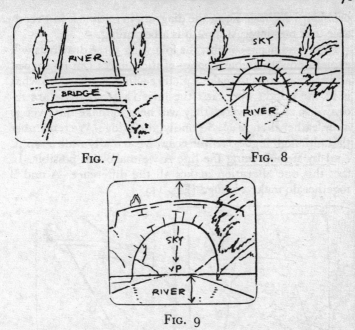

Fig. 7

Fig. 8

Fig. 9

and B (Fig. 10). The tree is usually depicted as a bush, any-how as a rounded form on one side of the river. And there the matter remains, in suspense! (If colour is used, the bridge

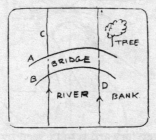

Fig. 10

is painted bright red, the river deep blue, and the rest a cold green. This certainly helps but it does not solve the main

problem). As basic signs, the diagram in outline is just read-able, but no more. At most it is a beginning.

Now if advice is sought, the following three drawings will explain how these bare bones of the subject can be shaped and covered so as to make a picture which conforms to what is in the mind's eye. First the lines C, D. If these are re-drawn so as to converge they will help to make the river *go away*, rather than *go up*! Secondly, the bridge. We remember that although it goes *over* the river, we actually walk *across* it. And by straightening the line A we make this possible. In fact this one alteration makes all the difference: A and B together do make a bridge (Fig. 11).

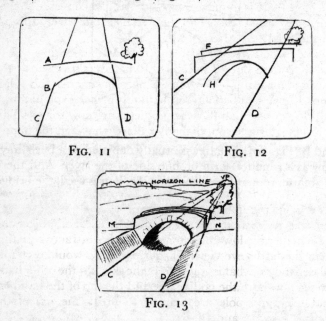

FIG. 11 FIG. 12

FIG. 13

Another big step forward is to be seen by drawing lines C and D diagonally instead of vertically up the paper. The river now does begin to go away. Giving our bridge a thick-ness presents a difficulty. We can add a parallel line F, above

our line A, but to make the arch look solid, the line E cannot
repeat the line B and we have to compromise by joining it
up to B somewhere in the middle of the curve H (Fig. 12).
Now we remember that when we walk across a bridge there
is a parapet or wall on either side which we can lean over.
How is this to be represented? Obviously by dropping two
short lines N and M from either end of A and B. But we still
have the problem of the river. Suppose we continued our lines
C and D beyond the margins of our paper? They would cer-
tainly meet in the end and at that point would be our
horizon line. So why not draw that line across, just below
the top of our picture? Now we have a strip of sky and all
we have to do is to make our lines C and D converge so that
they *meet on this line* (Fig. 13). At last our river appears
earthbound!

The top of each bank can now be drawn in, taking care to
see that these lines converge so that they also meet at the
vanishing point Z. The remaining adjustments and addi-
tions I hope can be followed without further explanation.

I do not say that all river problems are now solved! This
is just one instance out of many, where what is in the mind's
eye can be translated by means of one of the fundamental
rules of perspective, and that rule, which we have now
proved, is that for picture purposes the horizon line is de-
finitely wanted, if only to prevent our river, like a lift, from
always 'going up'!

Let us try this experiment with another sort of subject and
see whether the low horizon makes a more attractive picture
than the bird's-eye view. Of course, Fig. 18 would certainly
all depend on what is going on in the sky. On the other hand
we see how both the poplar tree and the top of the haystack
and telegraph pole are helping to break the *line* of the
horizon, Figs. 17 and 18.

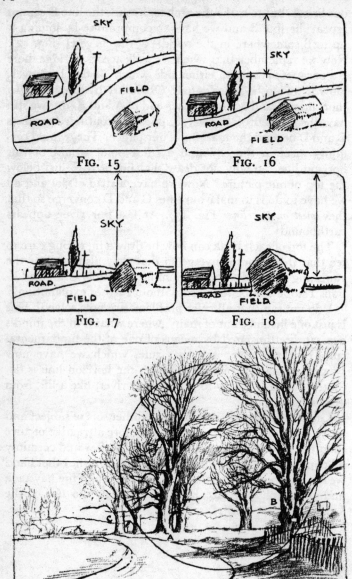

FIG. 15

FIG. 16

FIG. 17

FIG. 18

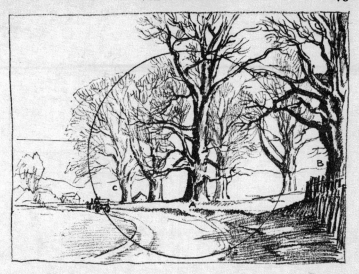

I hope that these examples are sufficient to show the important changes that occur when your subject is seen from different points of view, even though the change in position may be but a few yards apart.
The area of interest shifts the closer you approach the subject. Notice the positions of A, B, and C in both drawings

COMPOSITION

THERE ARE many weighty rules which govern composition, so many and so weighty that if you read them all I doubt whether you would ever summon up enough courage to start a picture! Certain it is that if you attempted to obey them all, half the joy of picture making would vanish under a cloud of anxiety and dread of forgetting one of the many 'indispensable' dictums which, like a series of motoring signs, line our timid route. Balance, Unity, Repose, Rhythm, Emphasis, Contrast, etc. – quite a frightening array of REMEMBERS, DON'TS, and WARNINGS. But composition, thank goodness, if it has vitality, must be flexible and not rigid. It depends indeed very largely on our mood and the subject matter. Pictorial conditions (and I was almost inclined to add 'climatic conditions') have a direct or indirect influence on our composition, and in the end our feelings transmute the various devices which we subconsciously employ, and for this very reason no formal analysis can cover all the complexities of pictorial composition.

Let us face it. Our picture in the end stands or falls by the amount of aesthetic enjoyment the beholder receives from it (not necessarily at first glance, although this can happen) over a period of time, and the longer the period that the picture retains our interest and stimulates our imagination, the better the picture, the *better the composition*.

I think that one golden rule, if clearly understood, will cover, if not all the other rules, enough to make no matter. And that rule is simply stated. It is this: our picture, whether it be a landscape, seascape, interior, or still life, must be so composed that the eye is lead *into* it, and not across it. How you achieve this I would say is your own affair. It can be obtained in many ways. Recession must come into it, for if we want the spectator to look *into* our picture, he must be helped by an illusion of depth. But chief among the many legitimate technical devices is emphasis – either of line or

shape – or contrast; some directions to a focal point to which the eye travels and is content to remain. Let us compare two compositions (Figs. 1 and 2).

Fig. 2 is certainly better than Fig. 1, but we still are led *out* of the picture though we do it in a more leisurely way, by a more oblique route. So we forcibly take the beholder by the shoulder and slowly turn him round and direct his gaze into the picture (Fig. 3).

But (and this is very important) this does not mean that Fig. 1 is ruled out altogether as a composition, even as it stands. We can still retain the general lines and by adding to our picture some other features in the right place, a balance can be created and a focal point introduced to arrest the original directive across and out of the picture.

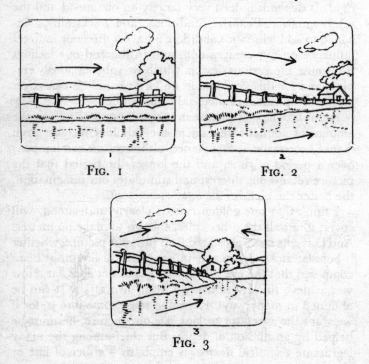

FIG. 1 FIG. 2

FIG. 3

In Fig. 4 we have introduced the form of a boat pointing *away* from the house, and a portion of foreground bank which narrows the width of the river on the right. Also the cloud has been moved over, and such devices can be seen to help counterbalance the interest of the house and tree.

In Fig. 5, more drastic steps have been taken to restore the composition. The foreground bank is now a definite pointer to the boat and then up the bank to the poplar tree. We now look *across* the river to the other bank, whereas in our original drawing (Figs. 1 and 2) we were looking along the river bank and hence out of our picture.

I have always maintained that an introductory platform as a base for our picture conveys a feeling of security and allows the spectator to feel his feet, as it were, before ad-

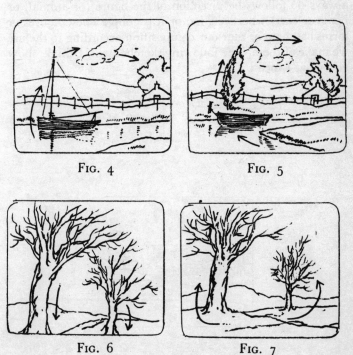

FIG. 4 FIG. 5

FIG. 6 FIG. 7

vancing into our picture. I don't like nature's forms to grow
out from the base of our picture: it gives an impression that
the picture has been cut down, or is a detail from a larger
composition. Especially true is this if we have strong per-
pendicular shapes, such as trees, in the foreground of our
picture. Let us have some *ground* in our foreground to stand
upon and admire the view. These two examples Figs. 6 and
7, will better explain what I mean.

The same of course applies to buildings or figures, and
lastly, I should say, be very careful if you are introducing
the human element into your composition that the figure or
figures you employ are looking (if they are standing or sit-
ting) into your picture, and if moving – then moving *into* and
not out of your picture. It is easy to slip up on this, but we
always do follow the direction of the figure (or animal, or
boat, or cart) wherever, he, or it is going. These figures or
forms can help or mar our composition according to the use
we make of them. The following sketches will, I think, show
you what I mean.

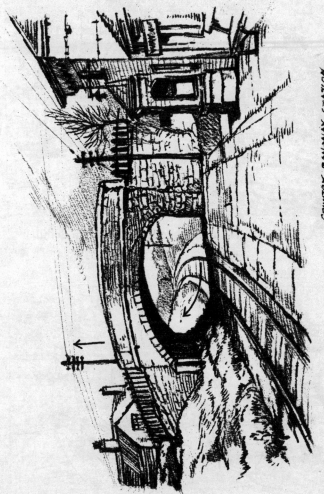

COUNTRY RAILWAY STATION.

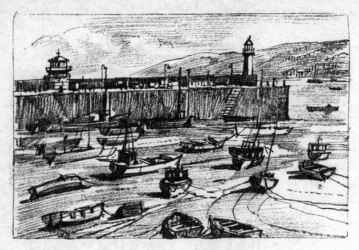

A. The composition is spoilt by too much detail

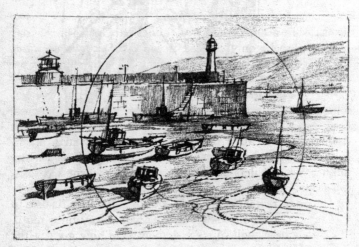

B. How elimination can improve the composition

PERSPECTIVE

WHEN THE student has overcome some of these more elementary problems of picture making, perspective usually rears its formidable head. To most beginners, perspective is a mathematical science, approached with grave demeanour and an armoury of geometrical instruments and complex postulates. For this reason I would advise a light-hearted approach, a 'hail fellow well met' salutation with the air of one who should say 'And what can you do for me? How are you able to *help* me?' De Quincey puts his finger on the spot when he says that 'unless a person has happened to observe in pictures how it is that the artist produces these effects (lines in perspective) he will be utterly unable to make the smallest approximation to it'. Yet why? For he has actually seen the effect every day of his life. The reason is – that he allows his understanding to overrule his eyes. . . . He does not know that he has seen (and therefore *quo ad* his consciousness has *not* seen) that which he *has* seen every day of his life. The axiom that parallel lines can never meet may be shown to be only correct, if you *insist on following them.* Directly you let them go their own way – by standing between them to watch their departure – you will notice that very soon they gradually begin to draw nearer to one another, and the farther they go from you, the closer becomes their association, until they actually do appear to meet and that is what is called the vanishing point. By such an informal introduction, perspective is robbed of its sinister application of rulers and T-squares, and is harnessed to its job of helping the student to improve on his composition, for that is its primary function. And to emphasize its uses in this respect, the four diagrams on the railway lines motif, illustrated here, will quickly demonstrate how greatly the composition is improved by *looking down* the track instead of looking *across* it. In Fig. 1 the beholder follows willy-nilly the lines of the rails and those of the fence, telegraph poles,

and hedge which all run across the picture and out of it, taking you with them! In Figs, 2, 3, and 4, the eye of the spectator is directed, in the first case, obliquely across the track (a step in the right direction), in the second instance, he is compelled to look directly down the track and slap into the middle of the picture, and in the last example (which is the best) he is merely *invited* to follow the lines, which curve gradually into the focal point.

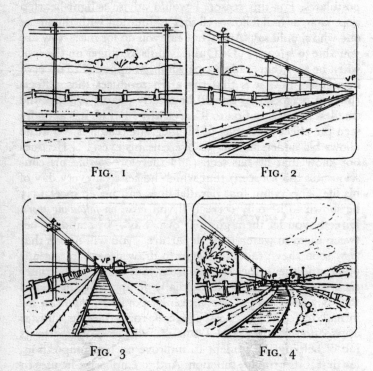

FIG. 1 FIG. 2

FIG. 3 FIG. 4

Without the help of perspective, the last three aspects of the subject would be beyond the powers of the artist, as the parallel lines would only rear themselves up on end and resemble the rungs on vertical ladders. It is also to be noticed that despite the identical similitude of the objects in the first

two versions, while in the first picture the details are mono-
tonous, in the second, the converging nature of the lines
makes for variety in height and size of every object drawn,
and this improvement is further enhanced in the last two
examples, when by looking down the railway lines both sides
of the track have to be included, necessitating the introduc-
tion of fresh detail, by which the pictorial interest of the
subject is still further heightened.

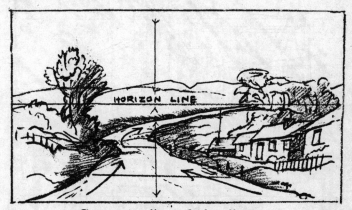

Converging lines of a bending road

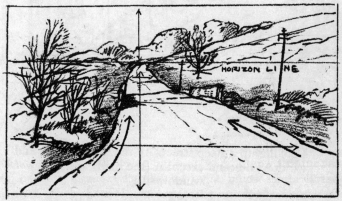

Converging lines of a straight road

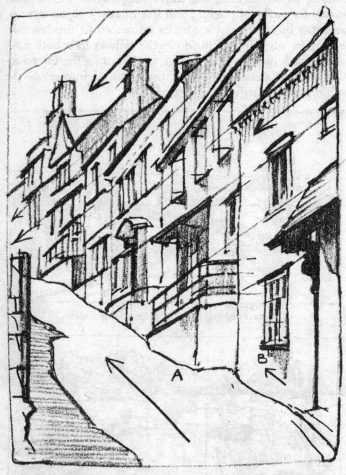

Looking up a steep street. All the lines of roofs and
windows descend except A (the road) and B (lower
window sill)

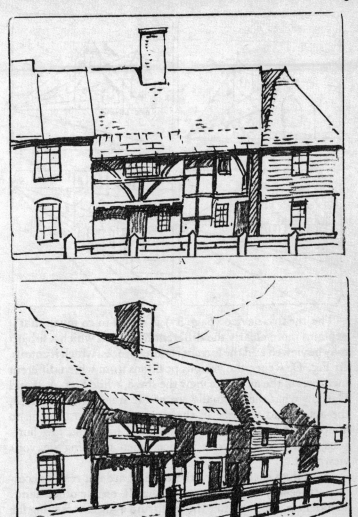

With the aid of perspective the line of cottages A is
transformed into B

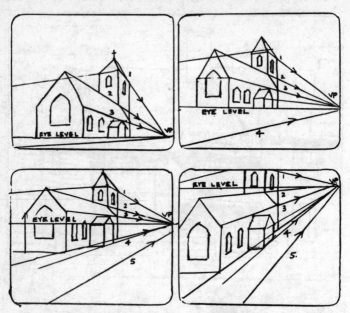

The theatre device (page 87) is useful in so much that it explains more clearly the different heights at which a subject may be viewed and the foreshortening process which it entails. In Fig. D, we see the various positions from which different members of the audience view the stage, while Figs. A, B and C, show what they actually see of the stage, the backcloth, the actor, and the tree in their proper relationship one to another, and reveal the advantages of high and low horizons, which are at your service when deciding on your viewpoint.

More than such hints as these I find are not really necessary, especially in the opening stages. If, on the other hand, a student is a seeker after the truth and evinces a craving for knowledge; to satisfy himself, for instance, that perpendiculars which subtend a greater angle than 60 per cent do appear to converge, then I pass him on to a text book on the subject – with a sigh of relief!

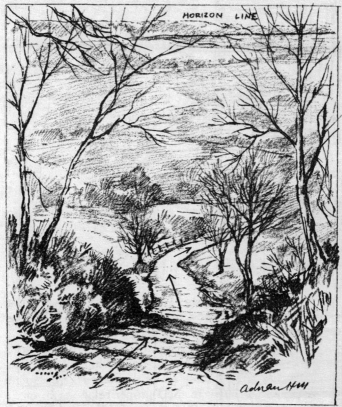

Looking down a steep path. Notice the high horizon.

Another simple way of explaining the fundamental law of perspective is to imagine that we are sitting at a casement window which opens *outwards*. Let us imagine this is what we see through the window when it is closed.

In Fig. 1, I have supposed we are looking *through* the glass at a grass plot at the bottom of which runs a fence, behind which a tree is seen and beyond that a distant hill. The line

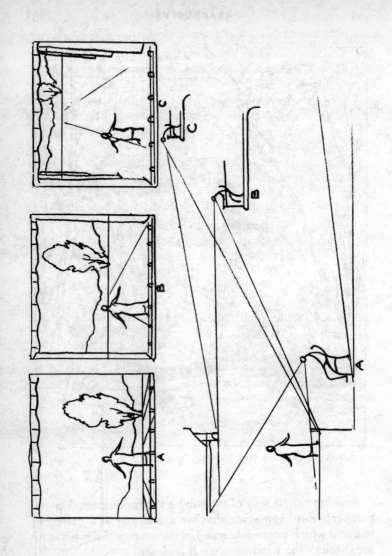

Another similar way of ... apparatus ...
apparatus, a transparent ... a ... in ...
window with opaque ... transparent ...
and through the window when it is closed.

In Fig. 3 I have supposed we are ...
...
...

of our fence is what we call the *horizon line* and that line is on the *level of our eyes*. If we stand up the fence will *rise* accordingly – if we choose a lower chair, the fence will be *lowered*. In short, the horizon line is *always on the level of our eyes*.

In Fig. 2, I have opened the window just a shade, or a 'crack' as we say. Now we see that the top and the bottom of the window are no longer parallel to each other, for while the top slants *down*, the bottom slants *up*.

How else, indeed, could we depict that the window is *open*, if we did not observe that these parallel lines do actually begin to converge and reveal the narrow strip all round the shape of the window? (X).

If we open the window wider we can now see its altered shape and if we continue the lines of the top (A) and bottom (B) we will arrive at a point on the horizon line which is called the vanishing point. We have now proved that parallel lines do actually meet in the end, if they are going away from us.

In short, all parallel lines which proceed to the horizon line *above* the eye level go *down*, and below the eye level go *up* (see Fig. 3).

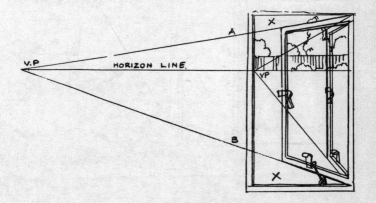

FIGS. 1, 2 and 3

USE OF THE SKETCH BOOK

A Word on Materials

THERE ARE now on the market any number of different kinds of sketch books to choose from at any artists' colourman. Stocked in all sizes, from the pocket variety to the quite impractical 'outsize' sketch book, they are made up in a very wide range of papers, including Bank, cartridge, and Whatman. There are thin sketch books and thick ones, sketch books with stiff backs and sketch books with limp covers, some perforated, some with a spiral binding attachment: sketch books, in fact, to suit all tastes, ranged in attractive ranks on the counter and in the window to tempt the enthusiastic sketcher.

So before I begin to discuss how to use a sketch book, I would like to say a word or two on how to choose one, for there are some of us who have a methodical turn of mind (although artists have not this reputation as a rule). Such readers will probably keep their sketch books very neatly, and, when completed, will arrange them in a sort of chronological order, labelling them with the title of their contents, for example, 'Rye, August', or 'London Parks', or 'Children and Animals', and so on. A student such as this will rightly purchase a book which is well bound with a stout cover, and will probably keep his records to a uniform size so that the completed books will make a neat appearance on a bookshelf. In passing I might add that I know an artist who has followed this practice for years, and his array of sketch books forms quite an impressive pictorial biography.

I must confess, however, that I am not one of these orderly practitioners. I have no love of albums, but generally tear out the drawings I want to keep as reference, and so in the end all the pages become loose, and I pile them together in a drawer against such time as I wish to use them. For this reason I have rarely indulged in an expensive sketch book; indeed many of my quick studies have been made in draw-

ing books which used to be on sale at stores boasting the sale of 'no article over sixpence'.

For more precise work, however, the book I have in mind is of squarish size, about 12 in. by 10 in., containing a thin-nish Bank paper, and possessing a stiff back. This type of sketch book I have found very serviceable for use with lead pencil, and for work that has to be done standing up.

A small sketch book made to fit the pocket is very con-venient for the swift recording of small details when one is out of doors, and I know many artists who always carry one – just in case. If you have a preference for carbon or conté crayon for making quick impressions, you should fix such sketches as soon as possible, as the constant rubbing caused by turning over the pages will soon smudge them. As I have used carbon a good deal, I always make doubly sure by de-taching each finished drawing and then fixing it. All things considered, a thin Bank or cartridge paper and B or 2B lead pencil give the best results.

I find that charcoal is never satisfactory for sketch book work. Although I have seen many 'layout' compositions attempted in this medium, the results have always been clumsy, and their meretricious effect wear off (literally) be-fore any practical use can be made of them. A fountain pen charged with special drawing ink which flows easily pro-duces virile, if not very accurate, studies, but I would urge timid students to try this medium to give themselves con-fidence. Coloured pencils are quite useful for recording local colour, but the suggestion is made that you use a cartridge paper, and a carbon pencil, as a slightly glossy paper and the slight greasiness of a lead pencil will make the process of working the colour over your drawing a tedious and unsatisfactory business.

I must warn the reader with his paint brush already poised that he will only court disaster if he imagines a vista of unalloyed enjoyment, without realizing that drawing should, indeed must, be accepted as a condition of the pro-mise. The urge to get on with the painting is very natural,

especially in these days when the amateur's free time is strictly limited, but if a love of drawing is not diligently cultivated the lack of it will be only too apparent when attempting to draw with the brush. Some students (even professional artists) find drawing with a pencil to be foreign to their nature, especially in the case of a hard pencil with a point. But it is just this very point, properly controlled, which will with unerring precision depict what is desirable when translating Nature in terms of colour.

On the other hand, if the student finds himself unable to wield a pencil, let him experiment with chalk, conté, or pastel, something more flexible and easy to manage. After all, it is all drawing, whether you use the side of a stick of charcoal or the point of a pen. Indeed pen drawing, where no alteration is possible, is an excellent antidote to pencil drawing, which can be erased, especially by the timid practitioner.

If I make a special plea for the pencil (I generally use a 2B) it is because in the following chapters I want to demonstrate its value with regard to your sketch book. The difficulty of impressing upon students the importance of this fundamental truth can be seen as soon as a request is made to inspect their sketch book. Oh yes, they have a sketch book somewhere, but they cannot lay their hands on it at the moment (because, if the truth be told, they have not used it for a long time) and anyhow there is nothing to see in it, they apologetically explain. If the book is reluctantly produced there is, as they predicted, nothing in it of any real value.

I have seen some of these haphazard sketch books. They have been started at both ends, used upside-down and on both sides of the paper, and the scribbles contained therein (which sometimes even include the beginning of a letter!) appear half-hearted and more resemble 'doodling' than anything suggestive of serious study. I have often suspected, unfairly perhaps, that modern tuition in some art schools may be one reason why sketching is a lost art, the student

being forever invited or coaxed to express himself straight-away with a finished drawing or painting. I know for a fact that some eager students find making studies as big a bore as practising five-finger exercises on the piano. I know also that such sketching is associated in their minds with a sort of specialist art. Their attitude is: if you can do it, it's great fun, but if you can't, what is the use of trying?

Now I suppose it is true in a sense that with practice it is a fairly simple job to make quite an *effective* sketch. A style is adopted, a conventional set of idioms learnt, and the subject of the sketch is made to conform to this scale of symbols. But if this sort of sketching is thought to be the subject under discussion, I hasten to disclaim any intention of favouring such practices, and affirm that my one aim and intention is to declaim such 'genteel accomplishment' as out of date. This I say without any undue acerbity, but from my own experience because I have personally made such sketches, probably hundreds of them!

Any of my older readers who remember a certain type of feature in art magazines of the last century, usually entitled 'Leaves from an Artist's Sketch Book', will recall their dainty sameness, technically attractive maybe, but alto-gether too dexterous in treatment to be of use to the student. I do not say that all such sketches have no artistic merit, but the majority would surely fail as *working* drawings. They are an end in themselves. They cannot pretend to be anything but charming impressions in pencil or chalk, and merely demonstrate the artist's facility in mastering a fashionable mode of recording the obvious. On closer inspection the handling is found to be to all purposes quite unreadable.

When we sit down to draw anything – and even if this is a truism it is worth repeating – we pass from merely *seeing* our subject to *considering* it, and all the time we are making our study we must, willy-nilly, concentrate our whole attention on its construction. Now this is the important point which can so easily be overlooked. When we are painting, our at-tention is perforce distracted by other problems, such as

light and shade, colour, composition, and the general conditions that influence our subject. We are faced with the whole battery of nature and thus we cease 'to caress the individual form', and contrive to see it only as an integral part of the whole design. It is only when we are making a sketch, therefore, that we are at liberty to investigate a particular part, and it is this study of detail which I wish to emphasize and which I hold to take first place in our sketch book.

Obviously this is not the only method of employing our time when sketching. Accurate drawings of details, like isolated studies of parts of the human form, can teach us little about the construction of the whole organism. But what we have drawn in part we should know something more about, and certainly more than if we tackled it in our finished painting without such preliminary study.

I defy any reader to make a study of the commonest object without an added interest being aroused by its shape and fitness of purpose. If you do not believe this, try sketching a chimney stack, a street lamp, a village pump or fire hydrant, or some homely kitchen utensil. Believe me, you do not really *know* them until you have drawn them and, if these haphazard examples appear exaggerated, try drawing any familiar object from memory, and you will soon be worried as to just how it goes.

At all events, I hope I have made it clear that there is no dearth of models in this sketching business, and in most cases they do not need rests – you can stare them out of countenance and they will remain unmoved.

The illustrations for this chapter are chosen merely to whet the reader's appetite and perhaps prompt him to reach out for his own sketch book and make a new attempt to sketch. In respect to disappointments that beginners are bound to meet with, it has been wisely said: 'Their work should be full of failures, for these are the signs of efforts.'

Procedure

Before making his sketch the student has to decide what is

the ultimate use to which he is going to put the study. If he is seeking detail for a picture he has already drawn, then the sketch should be executed with a fairly hard pencil and should include all the reference which *may* be wanted. I do not promise that the result will be very attractive as a sketch, as essentials will have to be hammered out and underlined, and it will probably appear very overcrowded, but if it is readable to the artist that is all that matters. The artist, and he alone perhaps, will be able to translate the symbols he has used. Any stylization of the technique will confuse the issue, and should be used only in another category of sketch, which consists in making a drawing for the sake of the study alone.

Such exercises are valuable in teaching the student to create and master a personal technique which has an artistic merit in itself. This technique will be modified or developed as his experience grows and will, of course, always be controlled by the circumstances under which the drawing is executed. The time factor alone makes great demands on the sketcher's ability to note down the subject with suitable precision so that 'the strokes of the pencil will flow into each other as naturally as the characters in cursive writing'.

It is likewise of little avail to set about a very careful drawing of some object which may, like a bus or a horse and cart, or even a tradesman's boy, move off at a moment's notice. In such a case a general impression must suffice, and by the use of a significant line and a sure touch some sort of harmony is automatically attained.

Finally, do not become a specialist in one type of sketch. Develop a love for drawing, learn to draw *firmly*, and always remember to forget to take out your india-rubber! There are ample opportunities for sketching, whether you be in town or country, in civilian life or in the Forces. I strongly urge you to take out your sketch book and make a good number of studies of a wide variety of subjects. Indeed, the more you draw the more you will want to draw, for you will be greatly encouraged when you realize how sketching develops your

artistic abilities and instils self-confidence in your powers of expression.

Types of Sketches

A rainy day and a disinclination for painting prompted an overdue tidy-up of one of my nests of drawers, and this chapter is mainly due to the explorations I made during my spring-clean. I store my sketches and sketch books in three architect's cabinets, each of which contains six deep drawers. They are full to overflowing with studies and sketches of all descriptions, amassed in the course of many years of work. From time to time I find it necessary to take stock of this mass of reference, weeding out those sketches that are now no longer worth keeping. Despite a fairly ruthless elimination, the residue is still quite substantial, and as I was arranging them in some kind of order (I have already confessed that by tearing out my sketches, I have reduced the books to a state of almost complete disintegration) it occurred to me that a description of what I found would furnish a clue as to how and when I made the study. Further, I thought that if I passed on this information, the reader might in a measure share my experiences and profit by my mistakes, of which there are not a few!

To the student, the collecting of such sketches is often, I believe, purely the product of a desire to record a number of charming snapshots of some holiday, to be shown to friends with the authority of a guide. In sketching abroad it is particularly advisable to remember that once the drawing is brought home it must suffice for your needs. You cannot dash backwards and forwards to confirm or augment any detail that now appears to need further explanation; too many of the little sketches I had made abroad have lacked integrity in detail. They looked well enough as sketches, but the multiple symbols had no tangible value – they were the conventional 'touches' of a bygone age.

The following drawings are typical of many studies I have made abroad. I do not pretend that these particular sketches

shed any new light on their pictorial possibilities; there is
nothing novel in their viewpoint, nothing personal in the
handling. They are what I would call thoroughly accurate
records and as such have a certain merit. They are easily
'read', and, because I took the trouble to fix the pencil, they
are as fresh as when they were drawn, and have served their
purpose on many occasions.

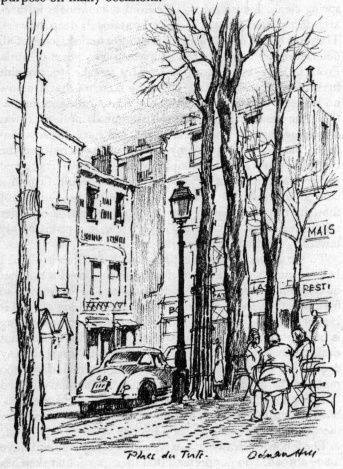

Place du Tertre. Adrian Hill

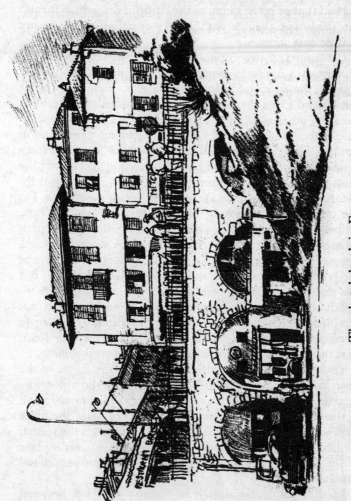

The sketch book in France

I boldly asseverate that there is no sketching ground abroad that offers as much as the British Isles, which furnish the landscape painter with nearly every aspect of nature that he can hope for.

Certainly, no two counties are alike, and nearly all can present two opposing types of scenery. This is noticeably true in the south of England where in such counties as Sussex and Essex the variety of terrain is quite remarkable. Like any other artist I have my preference for certain localities. Armed with a sketch book I have found more copy in Suffolk than in Cumberland, and more in the Home Counties than, say, in Berkshire. The fishing village and the bustling county town naturally provide more material for the pencil than the Lake District and Welsh mountains. On the other hand, sketching grounds such as Rye, St Ives, Polperro, and Brixham, which lie along our south coast, have been so thoroughly well explored that any sketch book devoted entirely to these picturesque resorts cannot escape the criticism of containing much that is all too familiar. But this does not matter as long as the studies one makes are individual records or impressions, and provided one is not tempted to choose the popular picture-postcard view or to draw the scene in a photographic way – for there is no doubt that the camera has a corrupting influence on sketching.

Your drawing should always introduce the factor of the *hand*, and if we grant the personal quality of the vision, the sketch will owe most of its expressiveness to the moving hand of the artist. Thus the more we 'chance our arm' the more our individuality is revealed in the drawing. It is the special faculty of the artist to invest with pictorial interest a place which may be so well known as to have been considered commonplace.

In that particular stretch of country that lies between Amberley, Arundel and, say, Chichester, there is still much for the trained eye to detect in unlikely quarters, and it is still the prerogative of the artist to spot 'winners' that remain hidden from the layman's eye. Incidentally it is in-

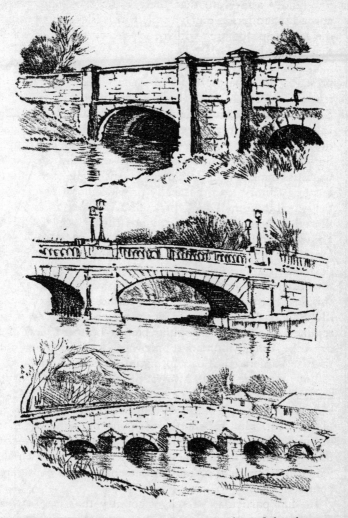

Note the difference in the construction of the three
bridge studies

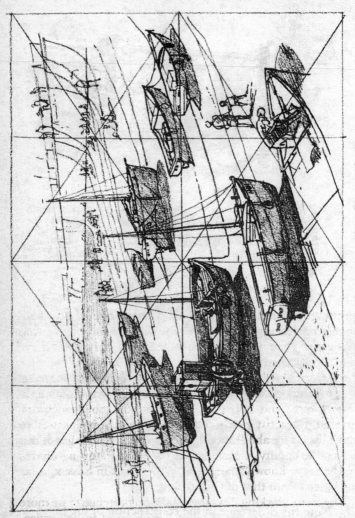

Working sketch, squared up for a painting

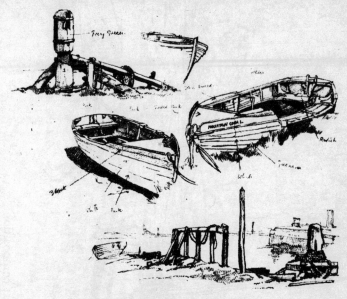

Boat studies with colour notes

teresting to learn what kind of country appeals to well-known painters, and to notice how far personal contact has influenced their work. The Cotswolds, in particular, have cast a permanent spell on some artists who have relied for the majority of their pictures on the characteristic material to be found in that fruitful district. Subjects abound in Oxfordshire, and it is easy to understand how, once discovered, the artist gladly retires from further exploration to make his future abode among the picturesque villages of this delectable county. I have found the same haunting charm on the lesser known marshes at Winchelsea in Sussex, a far cry indeed from that of Oxfordshire.

The frank working drawings make no pretence to be more than accurate accounts of what I considered to be serviceable material for an oil painting. The sheets of thumb-nail studies need little comment. My aim here, as in all sketches

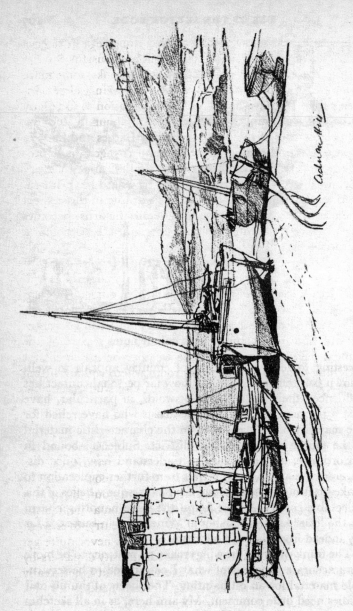

Study for a boat composition

of this kind, was solely to collect copy to be kept in reserve against the time when such detail might prove useful. Studies of this nature fill many pages of my sketch books, some more elaborate, as opportunity offered for making closer investigation. If I have not actually had occasion to use many of them, I was amply rewarded for my labour in studying the peculiarities of these mobile homes. Barges and bargees and the tranquil calling of these inland voyagers have provided another fascinating series of studies, and, in every case, my interest has been stimulated by what I have drawn. But I am not unmindful of Ruskin's warning in this respect when he says: 'By aiming only at detail, the artist becomes a mechanic; by aiming only at generalities, he becomes a trickster – his fall in both cases is sure.'

I have been able only to touch on a fringe of the vast field open to the enterprising student throughout the length and breadth of the English countryside, but enough has been said, I hope, to encourage the reader to explore and, of course, to take his sketch book with him. I will guarantee he will not return empty-handed, whatever part of the country he explores. And if the weather be inclement for sketching out of doors, the very room where you are sitting may well provide some subject for careful study, and that without your leaving your chair!

Street Sketching

Street sketching? I know this sounds rather frightening because it is so obvious that you must invite an audience. It is a consolation, however, to realize that in most towns the audience is mercifully a passing one, and your drawing is rarely subject to such an obdurate inquisition as is often the case in the country, when idlers stand sentry over your shoulder for an hour on end. Many artists never quite get over this aversion to the thick skinned curiosity of passers-by (who don't pass by!), but I have found that when really absorbed in the work, especially if I am making a quick sketch, I can mentally ignore their unwanted presence. Any-

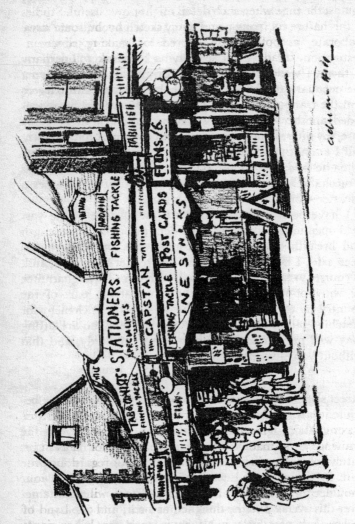

Seaside shops with advertisements

how it should never thwart one's resolve to sketch the things one wants to, whatever they are.

In the streets, parks, and squares of any built up area there is a fund of subjects just waiting to be noted down. Those of my readers who are new to the work will perhaps find more freedom if they go out early in the morning or on a Sunday, or at other times in the day when there are fewer pedestrians about. Then again one can always obtain a view from a window overlooking a subject which would lose in design if drawn from street level. Most street scenes, in fact, compose better if viewed from above. I have always found the owners of shops most accommodating in granting one facilities for sketching from their upstairs windows, and on one occasion I was even conducted on to the roof and handed up a chair, so that I could secure the right view and work in comfort.

Making studies for their own sake and for what can be learnt from so doing has always been a passion of mine as the accompanying illustrations show. All the sketches should be on the small side, for it is only by drawing to this scale that one can get beyond the unfinished study. Even then you will notice that many drawings are incomplete; in the rest I have jotted down just as much as I could in the time and then passed on to another sketch. The idea of filling a sheet like this with little studies must emanate, I suppose, from a desire to render such scraps more interesting from a pictorial point of view. After all why should a page of studies not have an aesthetic appeal? The artist should never forget that he is a designer first and foremost, and whatever he is drawing can be made to fill a given space well or badly. The old masters' drawings all demonstrated this regard for presentation. A sheet of little studies by Michelangelo, Paola Veronese, and especially Leonardo da Vinci, will prove this. They are really *pictures*, designed as such, and the hand of the producer can be seen clearly in each one. What giants the old masters were with a piece of chalk! Leonardo da Vinci could draw anything, and everything he drew,

whether it was a head or a pair of hands, a tree, or some wonderful idea for a new invention, was lifted from being 'just a study' to a work of art. How contemporary these studies are! They do not date but remain as alive today as when his hand first gave them birth. But I am reminded of Ruskin's timely caution: 'Nothing can be more perilous to the cause of art than the constant ringing in our painters' ears of the names of great predecessors as their examples of masters.'

So to return to us of weaker clay. We have a different range of subjects to contend with, and as everything is speeded up our problems are in some measure aggravated by this mechanized age. I have found, however, that pictorial expression is such a personal quality that the study of a motor lorry is as capable of being rendered as artistically as a hay cart, and in time will probably be regarded in much the same sentimental way. By this I do not mean to say that an accurate representation of everything the student observes should be included in his sketch book: selection is often required. But I do emphasize the importance of seizing every opportunity to note down contemporary aspects of life, bringing out the interesting qualities of shape and proportion which remain hidden from the uninquiring eye. A busy thoroughfare offers innumerable suggestions for this type of study, and so does the meanest cul-de-sac in the suburbs.

TREES

A LOT of beginners 'make' a tree (in full leaf) like this

FIG. 1

(Fig. 1). Rather like a cloud on a stalk! In a way it is quite an effective symbol. It is quite easy to see what it is supposed to be, but if it stops there, it gets very monotonous, especially when we see a lot of them all the same shape in a landscape: and we *do* see a lot of trees like this in a beginner's landscape. They never seem to vary in height or width. The first thing to do to get away from the likeness to a cumulus cloud is to *serrate* the simple curves and *vary* their *contours*

FIG. 2

(Fig. 2). This suggests a shape which is composed of lots and lots of little shapes – well, leaves, and by varying these contours, we suggest different sorts of trees, which is very useful, for no two trees of the same type are exactly the same, and the variety of types runs into hundreds! For instance, we get such different silhouettes as in Fig. 3; and each one of those trees is a slightly different shape when seen together with a similar *type* of tree. Take the first, which is the outline of a

poplar: in a line of poplars we get a variety of shapes, such as Fig. 4. All are slightly different, but all of the Poplar family.

We soon realize however that the plain outline of the tree is not enough, because the inside is not solid (though some evergreen trees are very dense and we only get glimpses of their branches and peeps of sky among the clumps of foliage). We know the inside is composed of a trunk and branches. So we must now see what a tree looks like before the leaves cover the branches, for these are very important. Leaves don't grow out of the trunk, but out of the twigs which grow out of the branches which grow out of the trunk! Thus we are driven back to the trunk, out of which everything grows, and it largely depends on the way the trunk grows as to what shape the tree ultimately takes.

Beginners do not readily draw bare trees but when they do they generally look something like this: (Fig. 6), which again is quite descriptive as a symbol. But as in our first exercises in drawing the tree in full leaf with the serrated

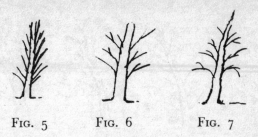

FIG. 5 FIG. 6 FIG. 7

outline – a succession of bare trees like Fig. 5 would prove very monotonous, unless we were purposely describing a young plantation of some specific tree.

The first improvement we would make is giving the trunk a thickness (Fig. 6), but if the thickness is the same all the way up, our drawing will not resemble a fully-grown tree, but only a section or lower half of a tree. By tapering the trunk gradually from the base till our two lines meet at the top we get Fig. 7, which is more like an entire tree! And now we have the difference between the thickness of the trunk and the thinness of the branches. Now we are really getting down to the *essentials* of a tree. How does it grow? – a main trunk, branches, and leaves in that order. The main trunk is more or less perpendicular, the branches more or less horizontal, out of which the leaves grow. (I am not speaking of the evergreen tree which we will take presently.) A tree in full leaf, we now realize, forms what can be loosely described as a solid shape of infinite variety. But underneath the clumps of foliage, we have discovered, lies the skeletal form of the trunk and branches, and it is their particular design, their *direction*, height, and width, which gives the tree its separate and characteristic *shape*. Let us see how this works out. First the bare bones, the basic lines:

Now, we give the main stem a *thickness* which tapers to the top and at the same time we give it a slight twist. But the lines which proceed out of the main stem (branches) also have a thickness and they divide into lesser branches (Fig. 8). Finally we should realize that these branches grow out,

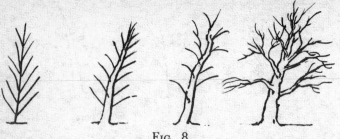

Fig. 8

not only from the sides of the trunk but from *all round* the trunk at varying intervals, and so we come to Fig. 8.

In the following diagrams you will see how these principles apply to other trees.

In each case you will notice that the branches are depicted at irregular intervals and are shown to spring from the trunk from *all* sides (Figs. 9 to 14).

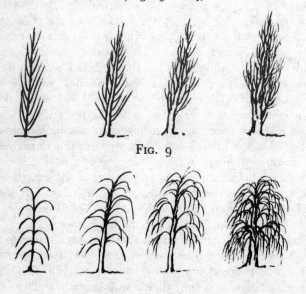

Fig. 9

Fig. 10

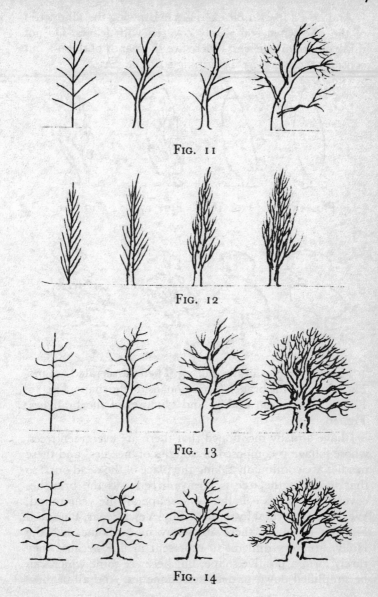

FIG. 11

FIG. 12

FIG. 13

FIG. 14

And now a few simple exercises in drawing the silhouettes of the tree when completely covered with leaves. Do not think of separate leaves – there are thousands of them – but consider them in *mass*, as forming a simple *shape*.

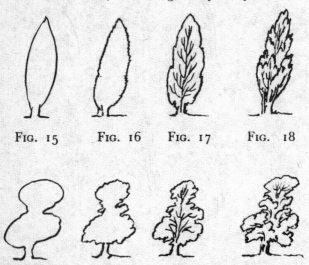

FIG. 15 FIG. 16 FIG. 17 FIG. 18

First the simple outline, Fig. 15. Then the serrated outline, Fig. 16. Then the branch formation inside the shape, Fig. 17. Finally the broken outline and glimpses of the branches, Fig. 18.

I have already mentioned that there are evergreen trees, whose foliage is composed of bundles of 'needles' and these needles are continually taking the place of the dead ones, so that in effect the tree is always green and the branches covered up. Thus it is the same shape all the year round. We all know several by name. Holly, Yew, Cedar, Pine, and Fir. But of course there are many more. Some, like the Holly, are very difficult to represent in line because they rarely form a positive shape, but here are some which can be simplified down to definite silhouettes. And all of these

can be used very effectively in ringing the changes on the
tree shapes in your landscapes, as will be readily seen in the
following sketches.

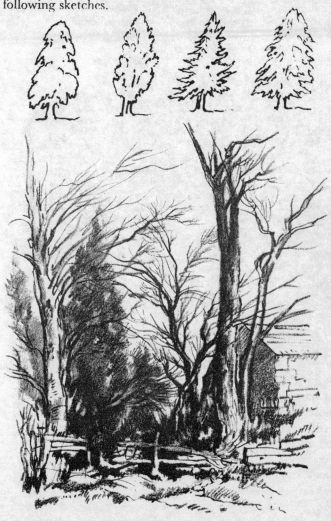

Strong tone is employed here to give density and
depth between the tree forms

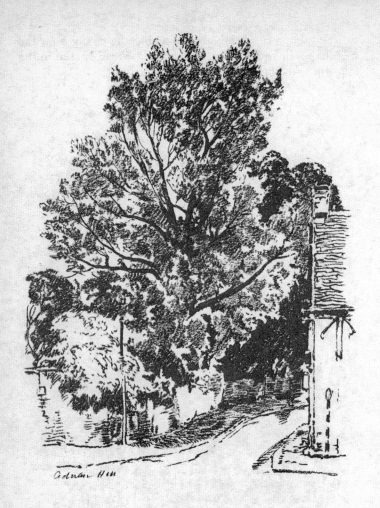

Suggested technique for foliage in strong sunlight.
The tree is an Aspen

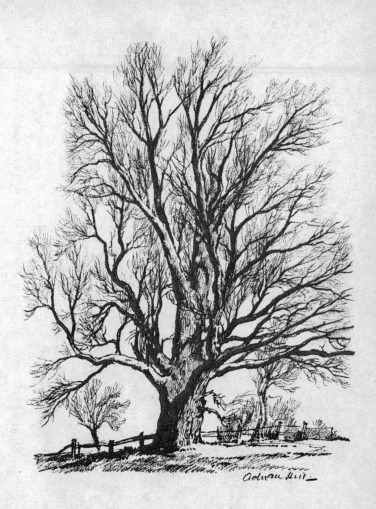

Study of an Ash in winter. Notice the projection and
recession of the branches

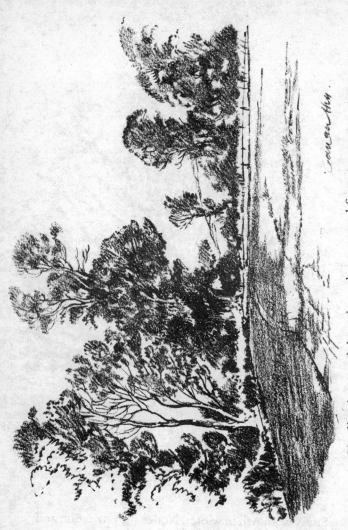

Shading is essential to give substance and form to summer trees

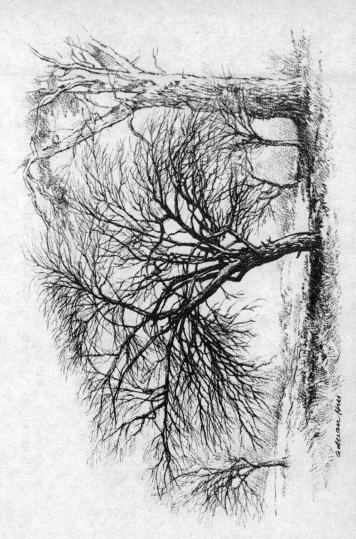

By introducing the Scots pine on the right, the size and nature of the *Pyrus Floribunda* is established

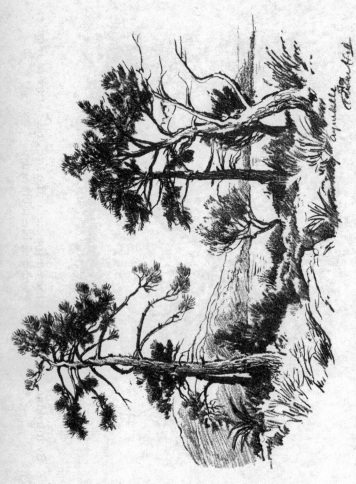

Notice how the use of tone links up the composition of the Pine trees and denotes the characteristic outline of the spikey foliage

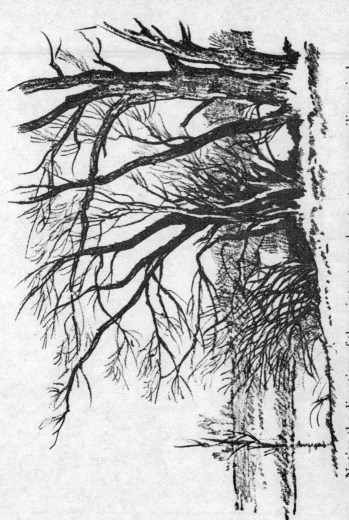

Notice the direction of the winter trees due to strong prevailing wind

HEADS AND FIGURES

IT OFTEN happens that a student who takes up Art manifests a desire to specialize in drawing portraits and people. The chief concern is with the human element as a stimulus to his or her aesthetic reactions and as a suitable vehicle for their expression. In order to cultivate and enlarge this response, especially if it be in the case of a very beginner, and without the facilities offered by an Art school course of study, any instruction must necessitate a simplified form of tuition which will serve as a foundation from which the student can make his own researches; a series of stages to which he can refer and from which his drawings will develop and grow in confidence. In short, the principles which control the human form must be demonstrated in such a way that the pupil has something solid on which to base his own conceptions. And the more simple and fundamental these rules are shown to be, the more elementary in their rudimentary symbols, the more chance there is of such standardized forms and diagrams being accepted and assimilated and the quicker the student will adopt them to his own reading of character and its subsequent expression.

It is unfortunately a well-known fact that a good likeness does not necessarily mean a good drawing. Indeed it is generally the reverse! The student (and I have had several) may have a keen insight into character and an almost uncanny gift of getting a 'speaking likeness' and still produce a head which lacks all sensibility, solidity, or constructional form. This is not surprising or unnatural. Any beginner who tries to draw anybody sets out with the one aim – to make it like them, cost what it may. It is this very urge that prevents the beginner from drawing a good solid head or figure. Now it is quite fatal to show your pupil how you personally set about the task. The magic of witnessing the swift creation of the features as depicted by your own personal touches, only leaves the beholder dumbfounded in admiration, entirely

mystified by the process, and utterly lost (in wonder) at the result.

I have found therefore that the greatest help can be rendered by the simplest means. And the simplest symbol by which one can demonstrate the third dimensional properties of a head is – roughly an egg! An egg made out of clay, solid but pliable. And in order to emphasize the rounded form, I build up the features in the following way. In Fig. 1,

 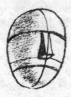

FIG. 1 FIG. 2 FIG. 3 FIG. 4

we have our egg shape with three lines (or pieces of string) drawn *round* the egg to denote the position of the eyes, nose, and mouth. To determine the position of the head, whether it is to be full face or a three-quarter view, another line is drawn this time *over* the top of the egg and *under* the 'chin' (see Fig. 2). Thus having fixed the position of the head and the lines indicating the relative placing of the features, the nose is symbolized by a triangular wedge which projects from the surface of the egg (see Fig. 3). On each side of this wedge, I scoop out two sockets representing two hollows *into* which I place the eyes (see Fig. 4). By these emblems the eyes will be shown to be *behind* the bridge of the nose and *farther back* than the brow or the surface of the cheek. To reach the eye on the right a line traced round the head will have to *surmount* the bridge of the nose and descend the other side, being lost to view until it passes over the farther eye and round the other side of the egg (see Fig. 5). I hope that repeating such words as 'mounting' and 'descending' and 'going round' will help to underline the importance of solid form, projection, and recession. The mouth I would describe as a gash or a slit, between the lips, which can now

be indicated. The ears are next introduced in a position roughly between the corner of the eye and wing of the nostril and as our head is a three-quarter view, the right ear will not show as it lies round the bend.

Having proceeded so far with the demonstration, our symbol of the egg has to be modified, especially in connexion with the chin, but enough has been established to prove the elementary principles, which may now be emphasized by taking up the profile of the face. It can be shown

FIG. 5

by a series of outlines of a side face that no matter how the features vary the tip of the nose will *always* project beyond the frontal bone or point of the chin. Also the socket of the eye can be shown more clearly in its relationship with the cheek and the bridge and tip of the nose and forehead (see Fig. 6). By these examples, the two most common defects in drawing a head, i.e. the failure to project the nose and recede the eyes can be effectually corrected.

FIG. 6

Top light from left

Side light
from left
and right

In constructing the figure, I recommend the use of the cylinder. The following diagrams I hope will explain how the body is built up and how it can be manipulated.

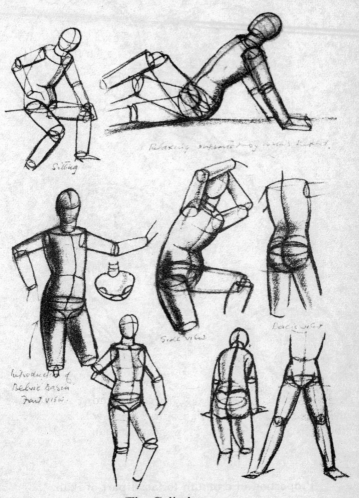

Sitting

Relaxing supported by arms & buttocks.

Introduction of
Pelvic Basin
Front View.

Side View

Back View

The Cylinder

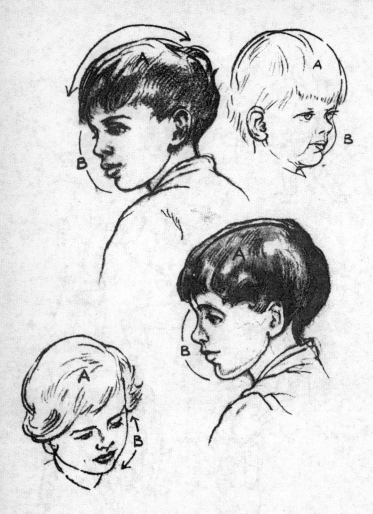

Proportion of cranium to facial part of skull
in children

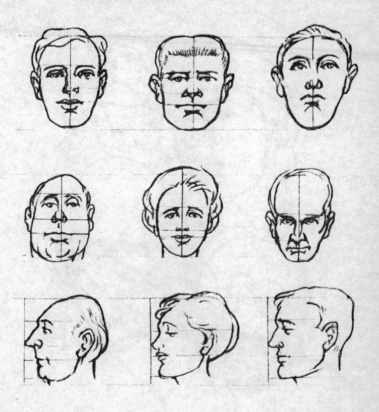

Proportion in portraying character and age

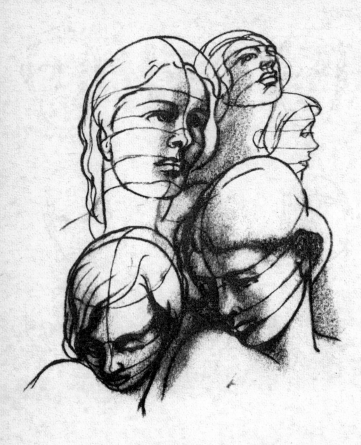

Relation of features to each other in various
movements of the head

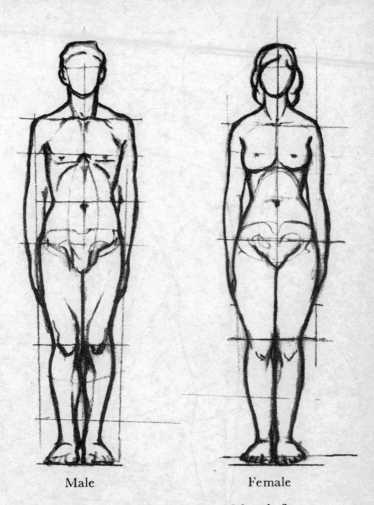

Male Female

Relative proportions of male and female figure

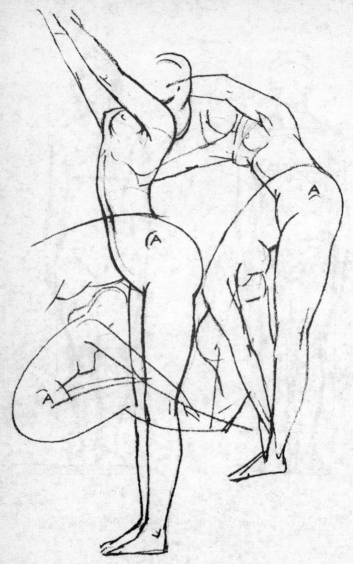

A. Where change of direction takes place

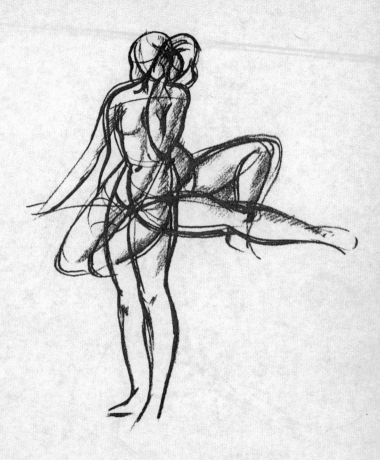

Flexibility of the figure – standing,
sitting, kneeling

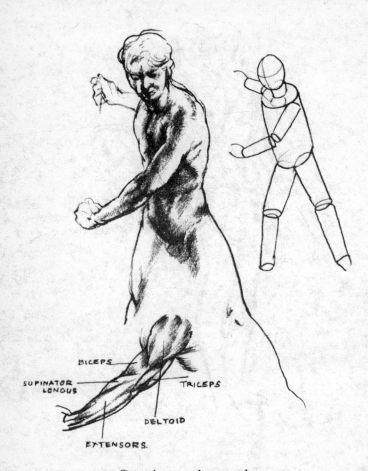

BICEPS

SUPINATOR
LONGUS

TRICEPS

DELTOID

EXTENSORS.

Covering up the muscles

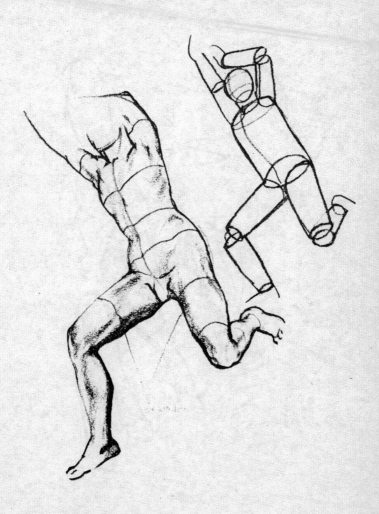

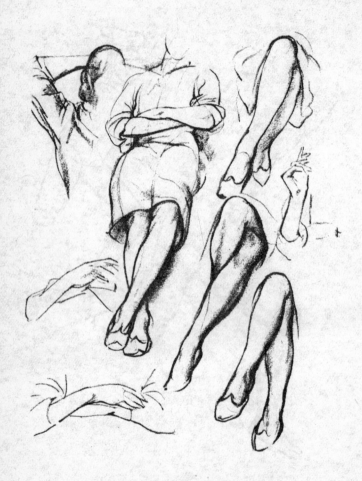

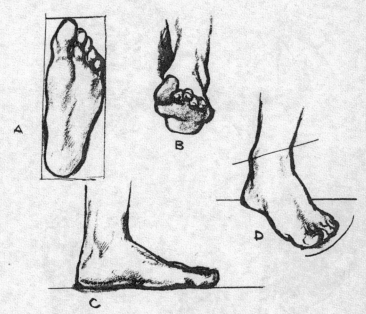

A. Shape of sole or flat of foot

B. Foreshortened view of sole

C. Side view of foot

D. Three-quarter view of standing foot

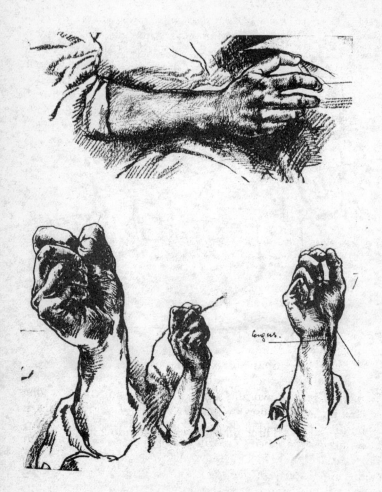

longus.

ANIMALS AND PEOPLE

HUMAN BEINGS and animals must both be considered as welcome ingredients in our picture making. People especially (sometimes to our cost) are to be found wherever we go! In the depths of the country, over lonely hill and moor, however anxious we may be to escape from our fellow beings, the human element is drawn towards us as if by a magnet as soon as we start to paint or draw. So we may as well make use of people, especially when they cross our line of fire!

With animals it is different, for they are more elusive. We generally have to find them. Go out armed with sketch book and pencil and, like a sportsman with his gun, we may spend a whole morning in a vain search for a quadruped, but stroll out without your materials and herds of cows will fairly block your path! It is wise therefore always to carry a sketch book. For picture purposes, cows and horses are the most familiar animals which can be safely and naturally introduced into landscape. They are the most commonly to be met with in a country ramble and when drawn correctly, can be used to great effect in heightening the interest of our picture. (Shades of Farquarson and the Victorian painters make me very dubious about sheep unless they are kept well in the background).

Let us take the animals first. Unlike horses, cows do mercifully sit down and sometimes even remain static long enough for purposes of making a careful study. There is nothing more solid in shape and more harmonious in its surroundings than a cow chewing the cud! Unless, of course, it is a herd of them in a meadow! And when thus encountered, the opportunity of making close-up studies should not be missed. But I must warn the student that although they appear to present the perfect immovable model, you will have to draw quickly as the sight and nearby presence of a human being soon disconcerts them. That and the flies cause a con-

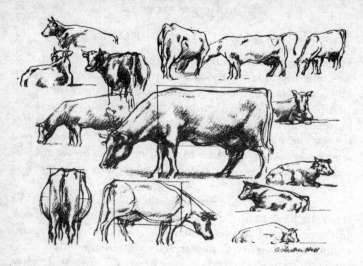

tinuous movement of head and ears, which sometimes only an outline will capture. Two points should be noted. Whether sitting or standing, cows have an oblong and squarish shape. The body is box-like, especially when viewed sideways. When standing or grazing silhouetted against the sky, this absence of curves is very noticeable. The hind-quarters seem to be cut off abruptly at right angles. Secondly, a cow's legs appear quite inadequate to support their bulk, notably when seen head on. And it is only in this position that the curves of the body are seen, bulging out each side and it is in this position, incidentally, that the bull is noticeably slimmer in width; otherwise its body is heavier, its neck far shorter and in all it is a much more ponderous and formidable beast! Indeed one only properly appreciates a bull at a distance, the greater the better, and it is seldom that one cares to approach near enough to make a detailed study, but if there is a fence between you and your model (as there was in my case) a bull can be even more obliging than a cow for taking a pose and keeping it.

Outline and proportion are therefore most important if

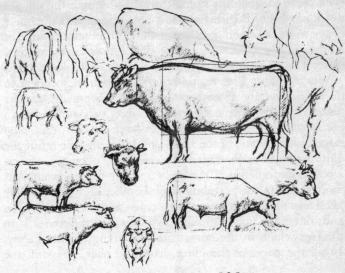

THE BULL.

one would escape from the danger of making your cow
somehow resemble a horse! For if the head. neck, and legs
are drawn too long and the body too curved, this unfortu-
nate metamorphosis may easily happen! When grazing, in
spite of their leisurely mode of progress, it takes a very quick
eye and hand to note the correct movement of a cow's legs
and one is driven, quite literally, to follow them around and
by a succession of outline studies, try and capture the alter-
nating action of fore and back legs. Sometimes one can go
back to a previous unfinished study and complete it, as the
cow repeats the movement. Unlike cows, horses are seldom
seen in numbers and in my experience rarely, if ever, en-
countered sitting down! (If they do, it is only to roll over in
an abandonment of kicking legs.) Despite all the difficulties
in capturing the characteristics of a horse's form, this animal
exercises a strange fascination for the young amateur. Chil-
dren especially love drawing (or trying to draw) horses. And
as I live in a county that is noticeably horse-minded and

even more so since my home town has become the official
headquarters of British Polo, it is not strange that the horse
has been forced upon my attention and his potential value in
landscape has challenged what skill I possess, to make a
closer study of these handsome and unpredictable animals.

When grazing I have found that, although they appear to
move as sedately as cows, their head movements are far
more wayward, far more varied. Bending this way and that,
horses continually straighten up to have a look round. The
same oblong shape of the body should be observed, but the
outline should be envisaged as a succession of curves, especi-
ally the underneath of the body and the hindquarters, but
more subtle in the undulations of shoulder and withers. The
head and neck are longer than a cow's and far more flexible
and, of course, graceful. The most marked difference is in
the legs which in the horse combine strength and pliancy.
In all the paces of the horse, from the walk, the trot, the

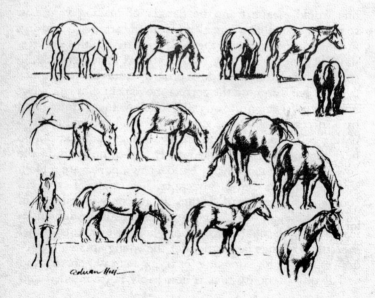

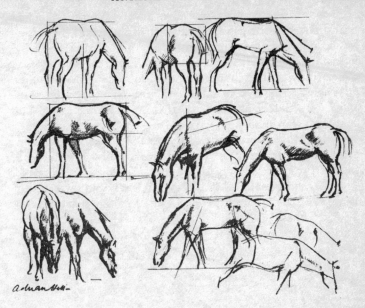

canter, to the hard and fast gallop, the leg movements represented in alighting, support, quitting and suspension, and alighting, are a miracle of mechanical beauty, and only through knowledge and constant observation (plus good photographic reference), can the horse in action be successfully recorded. Indeed, it is only when put out to grass with its head hanging over a fence that 'the old grey mare' can provide as motionless a model as the slow worker can hope for. And how pictorially effective can such an animal prove when depicted standing like a stone monument against a background of dark trees in some sequestered meadow! My drawings of the donkeys and those of the dog (a large friendly mongrel) may be added to this list of likely animals for models. The former stood patiently enough, bless them, while the latter was enticed to keep sufficiently still for registering a quick pose or two.

It is not in the compass of this book to dwell on the anatomical construction of these animals, nor to attempt to

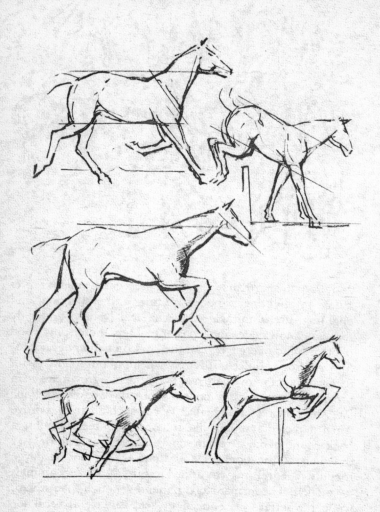

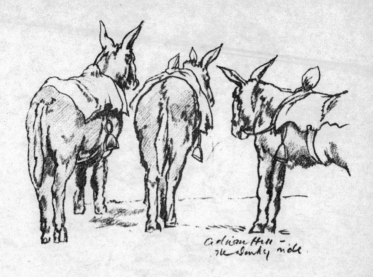

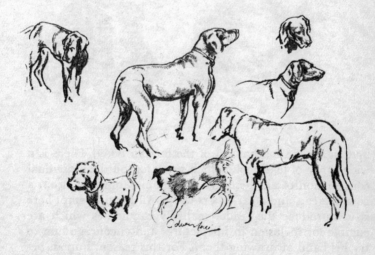

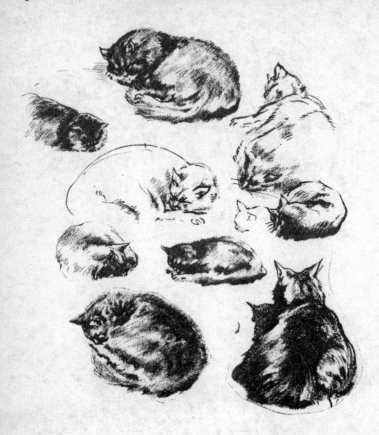

investigate the mechanism of the human body. There is a
wide range of text books which specialize on the individual
construction of all these live and inanimate forms, from a
cow to a car, and a car to a cowslip! All I can attempt here
is to introduce the reader to likely candidates which are
eligible for inclusion in his pictures and encourage him to
try his hand at drawing them. For this reason, human be-
ings, as well as animals, cannot be excluded from our list of
pictorial properties. A figure, as we have already seen, in

the right place can complete a picture, just as it can mar the composition if drawn in the wrong place. But before it can be introduced at all, we should try our hand at making separate studies of men and women. If the reader can work

from a window overlooking a street, it is an ideal way of observing the human element in action. The accompanying pages of drawings will suggest, I hope, how some types can be rapidly noted down. They are, as you will see, in outline only; there is no time for more. You can only hope to snatch at the fleeting position, so incredibly quickly do humans move!

Economy of line, then, is the first essential. There is no time for second thoughts and no time – at any time – for detail! An hour of such drawing will reveal the importance of proportion. Indeed it is the key word. Size of head to the length of body is so often overlooked. Most beginners, I have found, make the head far too large for the body, and the feet and hands (although they are a detail) far too small. Consequently their figures always resemble children. It is far better to draw the head on the small side (and the feet on the large) if the proportions of the adult are to be achieved.

Figures in repose (like sitting cows) offer a much steadier target and studies of those which I have included will be seen to be far more complete, for on several occasions my models were quite unaware of my designs upon them and sat or stood as still as anyone could have wished.

But perhaps the best advice I can give to those who are reluctant to attempt the human figure is to forget that it is 'human' and draw 'it' as you would, say, a bottle, regarding the all-over shape and concentrating on the outline which contains it. The head will then become like the stopper on a bottle, and the arms and legs as undulations of the solid mass. Again only practice can perfect this form of 'running script', whereby your pencil 'runs' round the silhouette and does not attempt to depict the individual members. You will find that by keeping your pencil on the paper (I do believe that is half the battle) and pursuing this follow through technique, you can speed up your drawing and consequently stand a far better chance of getting the whole figure (or animal) down. I always make a practice of starting with the head and whether the figure is front view or

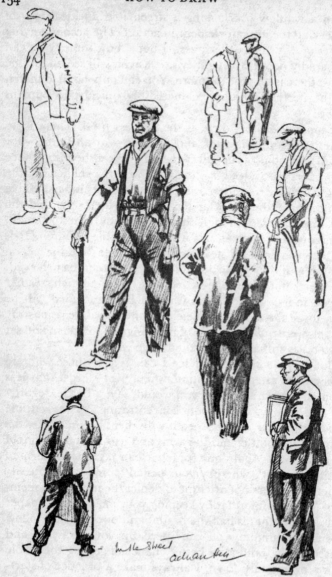

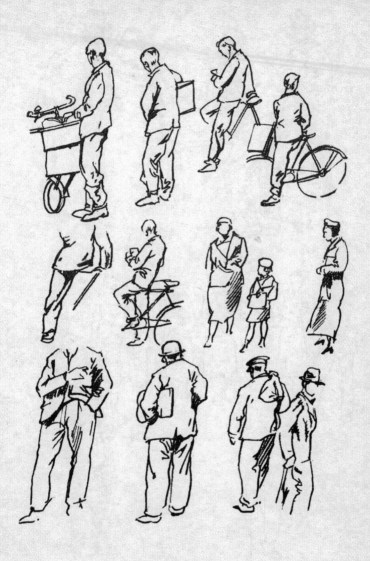

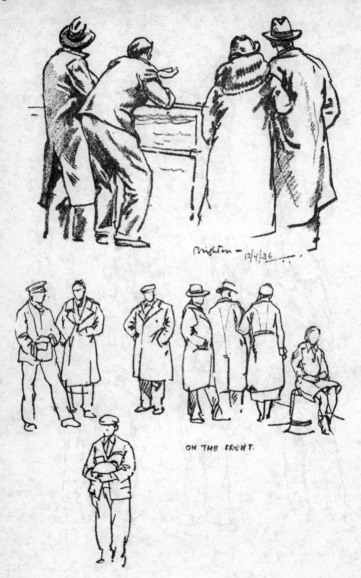

Brighton — 12/4/36

ON THE FRONT.

side, I continue round the shoulder and right down to the feet, if possible with no break in the line, and often I have done this while keeping my eyes fixed on my model! Of course you must look every now and again at what you have drawn, but if there are too many pauses for comparison you will be left with a series of incomplete studies, of which there are too many examples, I find, in my old sketch-books.

Two studies in Expression

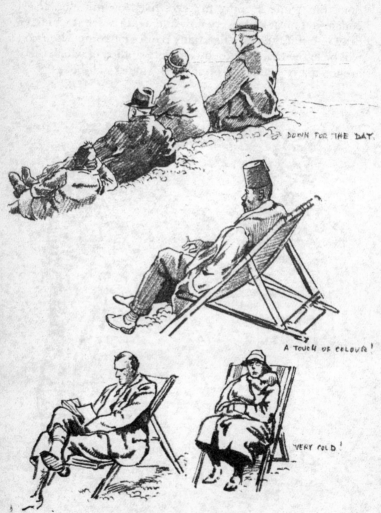

Brighton – On the Beach

A soft pencil for this 'stop watch' sketching will greatly help and in no case – unless of course your sitter has been asked to pose for you – will you ever have time to use an india-rubber. What is drawn must remain as you've drawn it, for when working against the clock there is rarely time for even a small correction.

In landscape we must remember that both humans and animals should always be subservient to the interest of the scene. They should be 'discovered' rather than proclaim their presence for then they will fit *into* the view and not be superimposed upon it. If they are required to dominate the picture, then the landscape must be relegated to background support, as an illustration to a story.

Having, as it were, 'limbered up', as the athlete would say, we can go into action in the open with increased confidence that if the subject we select contains or needs the human element we will be no longer shy of including it, but will welcome the opportunity which this test of skill offers.

COPYING AND USING A PHOTOGRAPH

FOR MANY years now the artist has increasingly welcomed the assistance afforded by the photograph. In some respects the practice of basing a painting on what the mechanical eye of the camera records has been greatly overdone. Now I maintain that very rarely indeed does a photograph from Nature fulfil all the requirements of a good composition and I believe there is a very real danger in pursuing this policy of losing sight of what we must surely still believe is a picture's chief attribute – its design, without which the result will be but an announcement and never wholly acceptable as a produced picture.

At first glance a photograph will often appear to add up to the conditions of an adequate composition, especially if it is well lit and made up of interesting forms. Let me give an example. For the illustration *Copying and Using a Photograph*, I have chosen what I consider to be a typical case of a striking photograph which, and please note, *contains* elements and suggests potential features from which a good composition can be made, but which, as it stands, cannot, I maintain, be literally copied without asking for trouble! In Fig. 1, I have tried to be fair to the original photograph (it would have been easy to exaggerate its faults), copying it as accurately as I could, with the result that you see. Quite an effective picture, good strong forms in the foreground making interesting silhouettes against the middle distance and the general effect helped enormously by powerful light and shade. What need we do more than copy these pollard willows darkly etched against the morning sun?

Now if the beginner had actually arrived on this scene he might very well have selected this same view, but I doubt very much whether he would have made a *square* picture of it, especially if he had been warned that for landscape the square is the most difficult shape to fill. But I equally doubt whether working direct from the photo he would have been

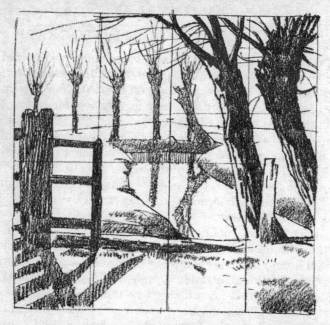

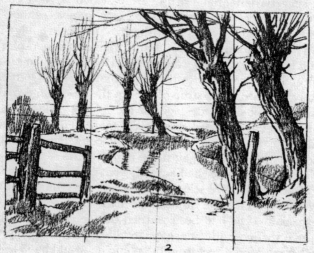

2

bothered to alter the shape. What the camera has done, however, is to show us what to concentrate upon and consequently what to leave out. In this case we do not see the crowning branches of the two foreground trees and only a fraction of the fence on the left of the posts. The beginner, I suspect, might have been tempted to include the whole of both trees and continue the fence, thereby losing half the effectiveness of the picture within the picture, i.e. the line of the distant willows which the camera has demonstrated can be framed by supporting forms *not necessarily seen in their entirety*.

In such manner the photograph has certainly solved a major problem for us, but, and it is a very big 'but', there the camera stops composing. It cannot (thank goodness for the painter) adjust, add or simplify anything in the selected view. True the photographer can change his position but then the result would be another kind of picture. As it is, and for what they are worth, many compositional errors come to light or should do, if a good composition is to be achieved. Do *we* want the supports of the fence to be quite so tall and rigid and the spaces between the bars to be so regular? Do *we* wish the line of background willows to be planted with such regularity and echo the perpendiculars of the fence? Surely we could dispense with some of the foreground, and need the bank in the middle distance run quite so parallel with the top of the fence? Could *we* do anything to prevent the tree on the extreme right from appearing to fall, say, by straightening it a little and showing its base? These and many more subtle little adjustments can be noticed in the lower drawing; the slight lean of the fence and its hint of being fore-shortened, the grouping of the far trees and the absence of the last tree on the left (which in the photograph appears to be growing out of the top of the post), the flattened curve of the stream; all these 'second thoughts' help to make the composition not only more pictorially satisfying but give the picture a more personal look. We are after all only exercising our right *as producer* of a given subject and

At least two compositions can be found in this wide angled view which is often what the camera tempts the beginner to copy in its entirety

not merely the slavish *announcer* of a series of facts, which in this case the camera has been shown to have no option but to accept and mechanically record.

But I repeat, the photograph has its uses. It can be a great saver of time, especially when we want authentic detail – in a hurry! It can freeze the moment in time and catch a passing shadow. It should never, however, be too faithfully copied for the reasons I've already given. Moreover, working from photographs deadens any personal approach and weakens the desire to go boldly out into the highways and byways to collect our information at first hand. Being a perfect fool with the camera myself I suspect I am more than usually prejudiced against the artist who always includes one with his sketching kit. And I definitely suspect that the so-called artist, who goes out with only a camera, to bag his subjects, is a pretty tame sort of artist.

DRAWING FROM IMAGINATION

I wonder whether anything positive can be said about such an autogenous activity as drawing from imagination? After all, what is self-produced is surely synonymous with self-reliance on one's ego and implies personal responsibility for what is created. Nobody can very well lend a hand in sorting out one's original thoughts or advise on their method of presentation, for both matter and manner spring from within.

There remains but one factor which might be worth considering. The starting pistol. The urge to be off. The will power to banish the censor. To seize a line and then follow it. Paul Klee was a fervent believer in the movement of lines and many of his pictures are witness to the lengths to which he went in exploiting what to him was a sort of creed. It can be summed up in his own alleged words, so often quoted as to be nearly always misquoted! – 'Going for a walk with a line.' What he actually wrote was, 'An active line on the walk, moving freely without a goal,' which is much more to the point. I always think this should be the accepted definition of the word 'doodling'. For when an artist resorts for relaxation to doodling he can be said to travel hopefully with no fixed purpose or destination. And such a carefree ('devil-may-care' if you like) adventure must promise a sequence of unusual happenings.

I would go so far as to say that no real (or what we term 'real') imaginative drawing can be plotted before it is begun. To know what you intend to draw before starting your pictorial adventure is merely to produce what I can only call an illustrated make-believe on traditional or accepted lines. But our imagination (and everybody can boast a little) cannot be marshalled in the artist's studio and marched off in step and with orders to proceed in a certain direction. It can only be *invited* to *assemble* and encouraged to explore when and where it chooses.

In the following examples, which I have chosen out of
scores I have done, you will see how completely fancy free
I was in following this artistic paper chase or treasure hunt,
for it must be explained that I picked up clues all the time

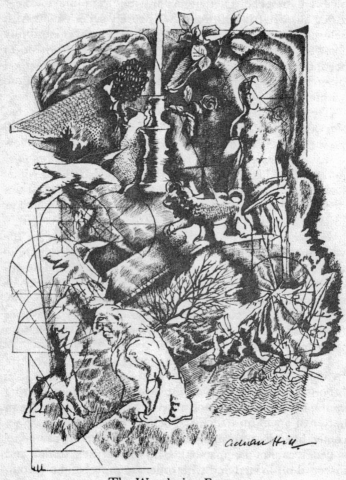

The Wandering Eye

from the external world. A drawing without them would have no meaning – at least for me. On the other hand 'without rhyme or reason' might well serve as a title for them all! For the reasons already given none of these pictures could have materialized if I had first asked myself, *what* shall I draw? For how did I know what was in store for me until I had actually begun the journey? There are actual things one thinks about and then draws, but these reproduced here are thoughts which *came to me while I was at work*. Such fancies arrive, as we say, 'out of the blue' (or what the psychoanalyst, I suspect, would describe as the 'deep sub-conscious' – it matters not). The fact remains that when one's pencil is receptive, willing to follow the unheralded subliminal artistic uprushes, the flow of free association will carry one on for some considerable distance, until – and this must be clearly stated – one has to take up the reins again and guide the steeds of one's imagination into the straight for home! At what particular point one takes control varies with each drawing, but the need to collect one's thoughts occurs (I find) when like children they show signs of fatigue and are ready to be *conducted* homewards, for that is the finish of the drawing.

It goes without saying that such drawings as these cannot be made without long apprenticeship in the control of the pencil. Freedom of execution can only come through tech-nical discipline. Make yourself master of your pencil and like a well-trained horse it will carry you safely wherever you wish to go, whether it be along the broad highway of traditional picture making or, as in this instance, over ditch and fence across the open country of your imagination.

To relax and daydream, to let one's thoughts wander with a pencil opens up a new and delightful prospect. Once you have learnt how to draw what you see about you with, let us say, a certain amount of accuracy – for that is important – you are then free to mix the material world with the world of fantasy and the results will be what one should expect from such new adventures in unexplored country.

Imaginative Landscape

Abstract Design

Surrealistic Still Life.

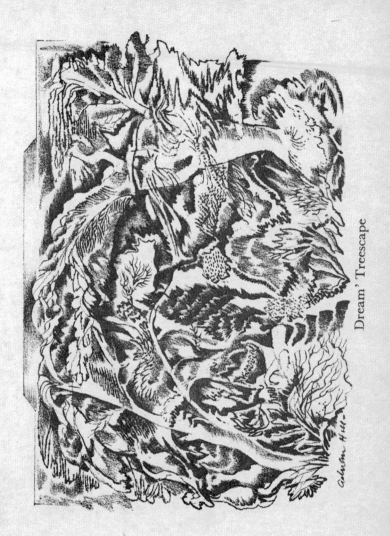

Dream ' Treescape

SOME CONCLUSIONS

AND HERE we must call a halt to these little adventures in line and tone. And the question, I suppose, that still remains to be answered is 'How far can we safely depart from the laws of Nature, so that our drawings are truly contemporary in outlook and execution?' We have seen how the vexed problem of perspective may be overcome. We have learnt how to solve the question of view point and when that has been settled, the various devices by which the eye of the spectator is led into our picture. We have furthermore grown wise as to what to leave out as well as to what to put in to our drawing. In short, all the well tried tips have been offered again but the doubt may still remain, how do these rules really help us to achieve freedom of handling, freedom of personal expression? Where is the necessity of learning the traditional approach? Are not all these regulations in almost complete opposition to modern conceptions of drawing? Would not the critic and the connoisseur vote many of them obsolete? And my answer would still be 'No'. To me they are still all indispensable rungs on the very ladder to complete freedom, both in subject matter and the way we approach it. For have I not suggested that in the very early stages the beginner should be encouraged to wander afield unfettered with as little technical equipment as is absolutely necessary for his first journeyings? And these only to be bounded by the limits of a certain size and shape. Have I not said, 'Here is a line, take it and see where it will lead you and what it can make?' The laws of composition were not even hinted at. Perspective played no conscious part in these trial runs, neither was light and shade nor solid form allowed to confuse the traveller. And yet we were already on the first rung of the ladder for we were learning one of the most important principles of drawing, how to use our pencil as an instrument for making the journey – *our own* journey.

Once started, or rather once off to a good start, as I have

explained, adventures will be met. The beginner will run up against obstacles, arrive at dead ends and lose his way. This is inevitable. Then comes the call for assistance – an SOS perhaps! And the breakdown outfit comes along. The advice given is purely technical and this is what has been hopefully offered in the preceding chapters, namely, how to become better equipped for continuing the journey. And when the check up has been completed and the defects (in drawing) made good, the student is ready to launch out again, in whatever direction and in whatever fashion he deems wise for his artistic wellbeing.

He may now discard what has been found cumbersome or redundant as well as retain what has been found absolutely necessary. He is at liberty to jettison anything in his equipment as long as it has been proved out of date or worn out. But let me just say this. Before throwing anything overboard, let us re-examine it to make sure that it is being used in the right way or in the right place or at the right time. For I verily believe that there is a place for every sort of drawing in all pictures, and if the technique is personally felt it will always be found worthy of the occasion.